MESSAGES
from TAHRIR

أموت في ميدان التحرير
ولا تحكمني .. وأعيش ذليل ...

هترحل يا مبارك ...

I would rather die in Tahrir Square
than have you govern me
and live in humiliation...
You will leave, Mubarak...

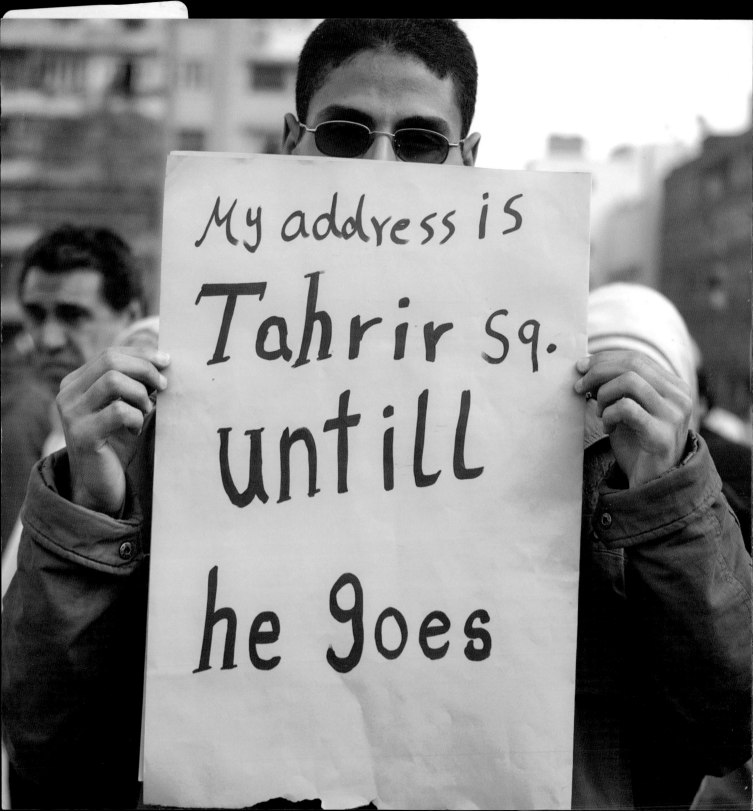

MESSAGES
from TAHRIR

Signs from Egypt's Revolution

Edited by **Karima Khalil**

The American University in Cairo Press
Cairo New York

For Laila and Max

First published in 2011 by
The American University in Cairo Press
113 Sharia Kasr el Aini, Cairo, Egypt
420 Fifth Avenue, New York, NY 10018
www.aucpress.com

Dar el Kutub No. 4824/11
ISBN 978 977 416 512 2

Dar el Kutub Cataloging-in-Publication Data

Khalil, Karima
 Messages from Tahrir: Signs of Egypt's Revolution / Karima Khalil.
 —Cairo:
 The American University in Cairo Press, 2011
 p. 156 cm. 21x21
 ISBN 978 977 416 512 2
 1. Egypt—History—1981 2. Revolution I. Title
 962.055

1 2 3 4 5 6 14 13 12 11

Designed by Amr el Kafrawy
Printed in Egypt

EGYPTIAN
come demand your
RIGHTS

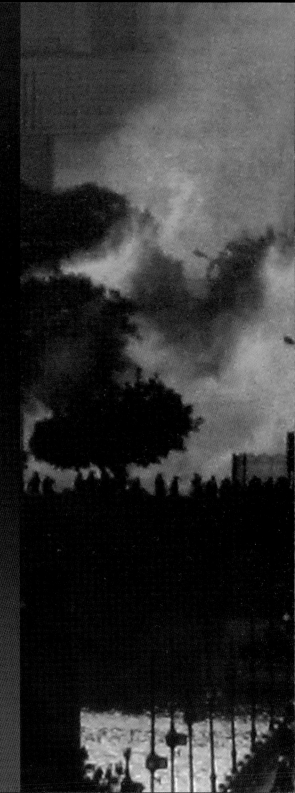

18 DAYS THAT CHANGED EGYPT
25 January - 11 February 2011

25 January
The "Day of Rage"; unprecedented anti-government demonstrations across Egypt.

27 January
The government blocks Facebook and Twitter, demonstrations continue.

28 January
"Friday of Anger"; huge demonstrations converge on Tahrir Square; internet and mobile phone networks are shut down. Hundreds die in street battles. Protesters occupy Tahrir and army tanks roll into the city.

29 January
Mubarak shuffles the cabinet and appoints a vice-president for the first time in 30 years.

1 February
Huge numbers descend on Tahrir. Mubarak announces he will not seek a sixth presidential term.

2 February
The "Battle of the Camel"; Mubarak supporters storm Tahrir on camel and horseback and fierce street battles continue through the night.

4 February
The "Friday of Departure"; hundreds of thousands protest peacefully in Tahrir and across Egypt.

7 February
Wael Ghoneim, founder of the anti-torture "We are all Khaled Said" Facebook page, is released after 12 days of interrogation by State Security. His TV appearance the same day moves many Egyptians to join the protests.

8 February
Tahrir Square sees its largest demonstration yet.

10 February
The broadcast of an army declaration raises expectations Mubarak will leave. Mubarak makes a speech but does not resign.

11 February
Protesters march on the presidential palace in Heliopolis. Mubarak steps down.

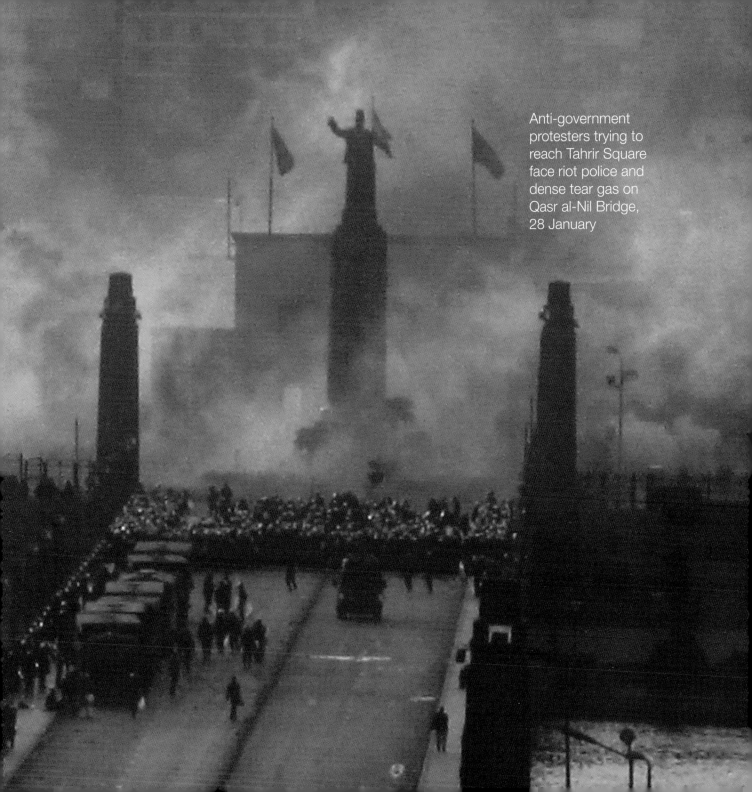

Anti-government protesters trying to reach Tahrir Square face riot police and dense tear gas on Qasr al-Nil Bridge, 28 January

INTRODUCTION

THE momentous protests that engulfed Egypt on 25 January 2011 brought down Hosni Mubarak's thirty-year authoritarian presidency eighteen days later. The story of the 25 January Revolution is the story of how a modest demonstration planned by activists expecting to be arrested within the hour turned into a nationwide uprising with Cairo's Tahrir Square as its epicenter.

In late 2010, a handful of young activists from the 6 April pro-democracy movement planned to make their annual demonstration marking Police Day on 25 January, bigger than its usual fleeting protests. They collaborated with other Egyptian youth movements, studying peaceful protest methods and staging flash demos around the country. This time they also had help from a 500,000-member Egyptian Facebook page, "We are all Khaled Said," which spread the call for a "Day of Rage" against police brutality.

Six months earlier, on 6 June 2010, 28-year-old Khaled Said was dragged from an internet café in Alexandria and beaten to death in broad daylight as he begged for his life. His family released a photograph of his disfigured face, which went viral on the net. "We are all Khaled Said," administered by Google executive Wael

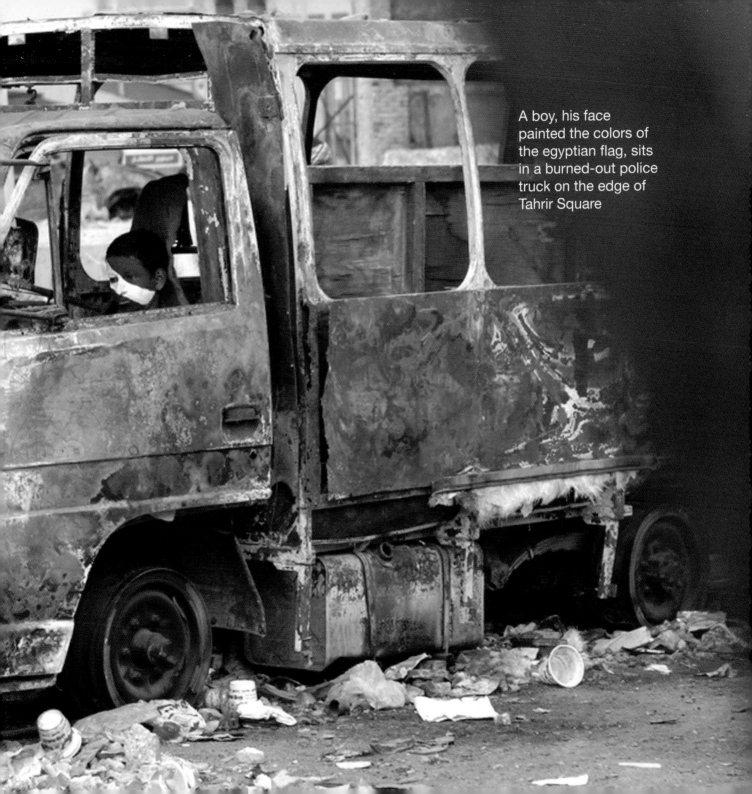

A boy, his face painted the colors of the egyptian flag, sits in a burned-out police truck on the edge of Tahrir Square

Ghoneim, galvanized long-suppressed public outrage against routine police torture, and quickly spearheaded the social media's role in mobilizing social protest against the regime. If Khaled Said's killing was the spark that ignited Egyptians' long-repressed anger, the overthrow of Tunisia's autocrat Zine El Abidine Ben Ali on 14 January 2011 made millions across the Arab world realize that change was possible.

On 25 January the demonstrations wildly exceeded their organizers' expectations. Tens of thousands of protesters marched to Tahrir Square in central Cairo, staging a sit-in for a few hours before armed riot police mounted a furious midnight assault. The police brutality only strengthened the protesters' resolve to return.

On Friday, 28 January—dubbed the "Friday of Anger"—up to 800,000 protesters spontaneously converged on Tahrir from every corner of Cairo; simultaneous protests swamped every large Egyptian city. The government panicked and cut Egypt's internet connection to the outside world and disabled mobile telephones. Unarmed civilians confronted police under dense clouds of teargas; these blasted buckshot and rubber bullets into the crowds, sprayed them with water cannons, drove into them with armored vehicles, and shot at them with sniper fire. Incredibly, the regime's feared riot force was beaten, by sheer bravery and force of will. At sunset, the police

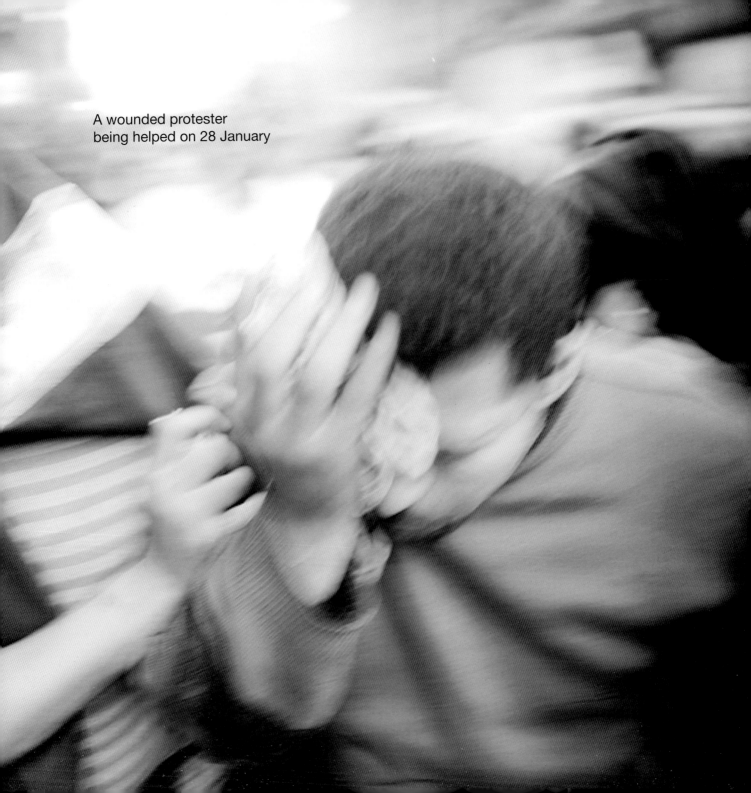

A wounded protester
being helped on 28 January

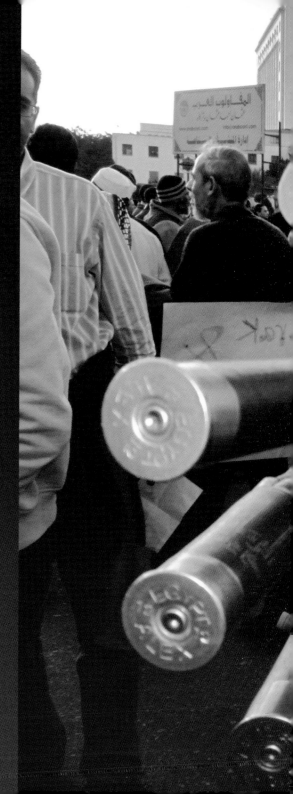

withdrew. The protesters had taken Tahrir Square, and vowed not to leave it until the regime was brought down.

Some 800 Egyptians died that day and thousands more were injured. Yet the tragic toll only heightened the protesters' determination to hold their ground and galvanized more citizens to join the protests. The army moved into Tahrir on the night of the 28th and declared it would not open fire on citizens. Almost immediately, growing numbers of ordinary Egyptians of all ages and backgrounds came to the square to express their hopes and dreams of a better future.

As the days passed, the sense of solidarity in Tahrir strengthened and grew. Egyptians from different backgrounds were often seeing and truly interacting with each other for the first time. Events quickly revealed how cohesion and harmony gave them strength. On 2 February, in what became known as the "Battle of the Camel," paid thugs wielding whips and clubs galloped into the square on camel and horseback in a brutal attempt to stampede the crowd, now hundreds of thousands strong. Molotov cocktails and masonry were hurled at protesters from rooftops. The battle continued through the night, with snipers picking off demonstrators. The square's unarmed defenders erected makeshift barricades and women ripped up

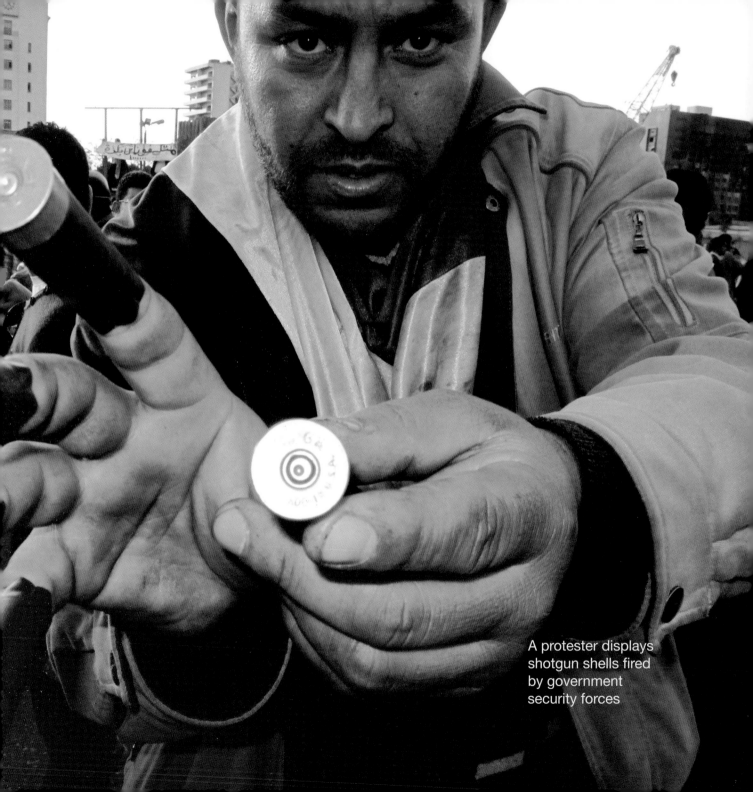

A protester displays
shotgun shells fired
by government
security forces

sidewalks with their bare hands to use the paving stones as projectiles. Eyewitnesses report acts of astonishing bravery. Doctors volunteering in the square's makeshift clinics tell of bandaging the same wounded citizens more than once, only to see them race back to the battle lines. Many, some as young as 13, did not survive. The attackers withdrew at dawn on 3 February and the square was the protesters' once again.

Over the days that followed, while young men and women defended the square's perimeter in shifts, cheerfully frisking the hundreds of thousands who came from all over Egypt, Tahrir became a locus of self-expression. To be there was to feel as if an enormous burden had been lifted, allowing for the demonstration of hopes and feelings that Egyptians had despaired of ever retrieving, feelings of pride in being Egyptian and of a wondrous empowerment granted by the square's communal spirit.

These profound emotions inspired an astonishing and spontaneous explosion of creativity in the square. Political oratory, rhyming chants, musical performances, and comedy skits were all there. Thousands, voiceless for so long, chose to express their feelings in writing. Signs made of paper, cardboard, fabric, bandages, and even shoes declared a multitude of eloquent messages. Some of these were somber, even tragic, telling of loved ones killed in Tahrir. "My son, the martyr,"

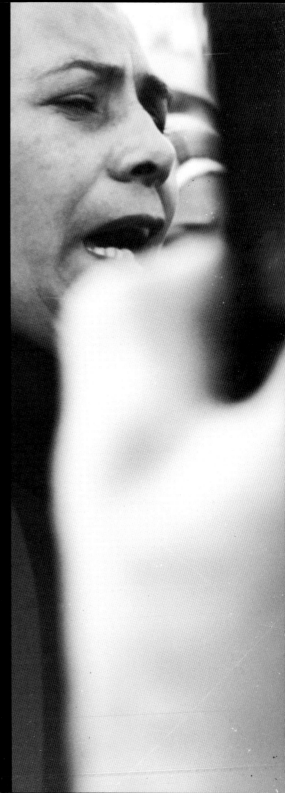

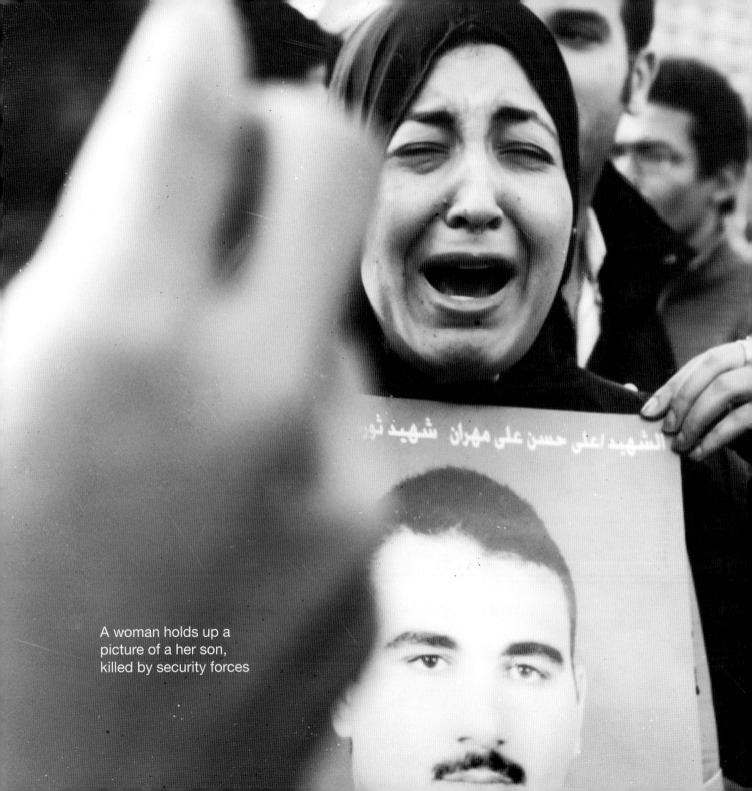

الشهيد /على حسن على مهران شهيد ثور

A woman holds up a
picture of a her son,
killed by security forces

was a sign sadly seen carried by many shocked and grief-stricken parents. Countless others declared their determination that the president step down, demanding in a variety of ways that he leave: "Go; Leave; Get out; Fly Away; We Hate You" were only some. Still others showcased Egyptians' famed irrepressible and scathing wit: "Hurry up, I've got exams." Messages were spelled out in rocks on the ground and written on kites flown above the crowd. A fraction of these remarkable messages are collected here, in images largely captured by non-professionals who went to protest in Tahrir and were moved to record what they saw.

Tahrir (which means 'Liberation' in Arabic) became the site where hundreds of thousands of Egyptians found personal liberation, and where, working together with extraordinary determination, patience, ingenuity, and good humor, they achieved the liberation of their country.

At sunset on 11 February 2011, a brief televised address announced the stepping down of Hosni Mubarak as Egypt's president. In Tahrir Square, the news rippled across a crowd already a million strong; thousands more poured into the square to join the jubilant celebrations that engulfed the country for several days. For Egypt's revolution, it was the end of the beginning.

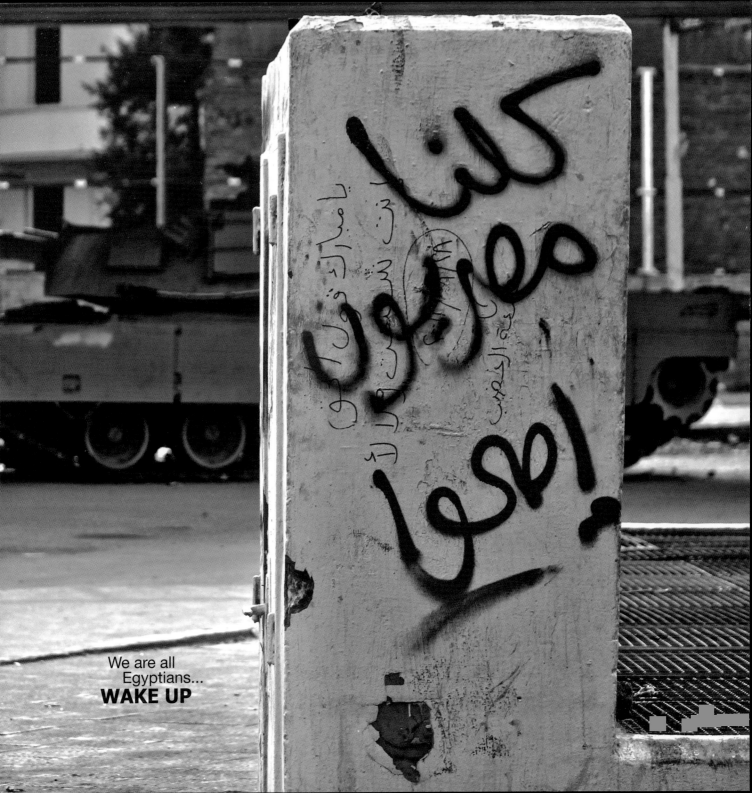

We are all
Egyptians...
WAKE UP

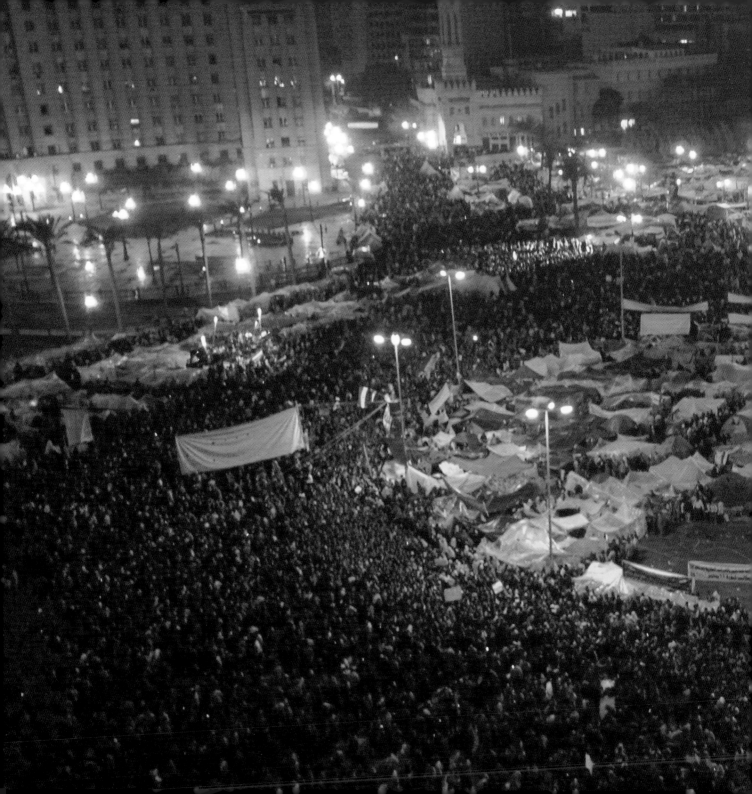

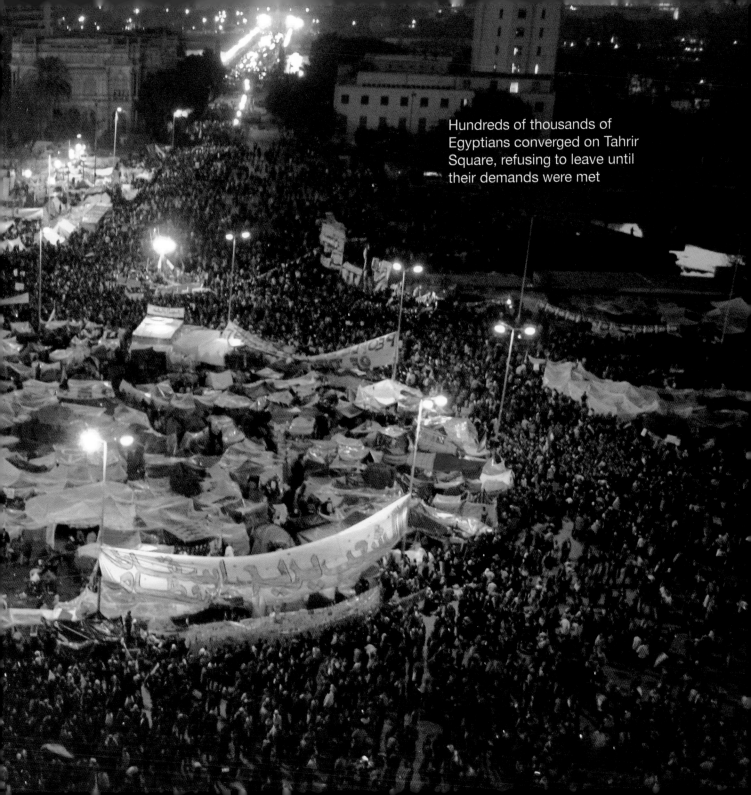

Hundreds of thousands of Egyptians converged on Tahrir Square, refusing to leave until their demands were met

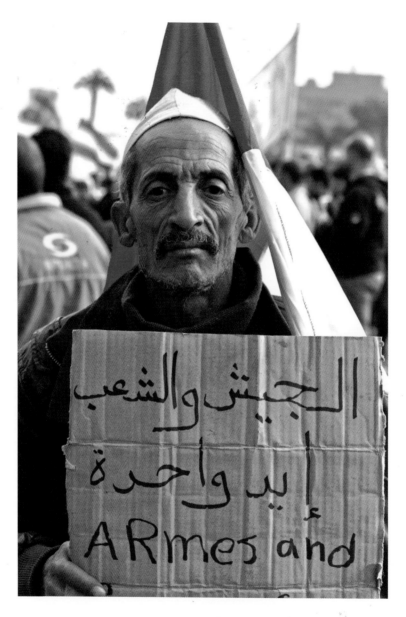

The army and the people
are one hand

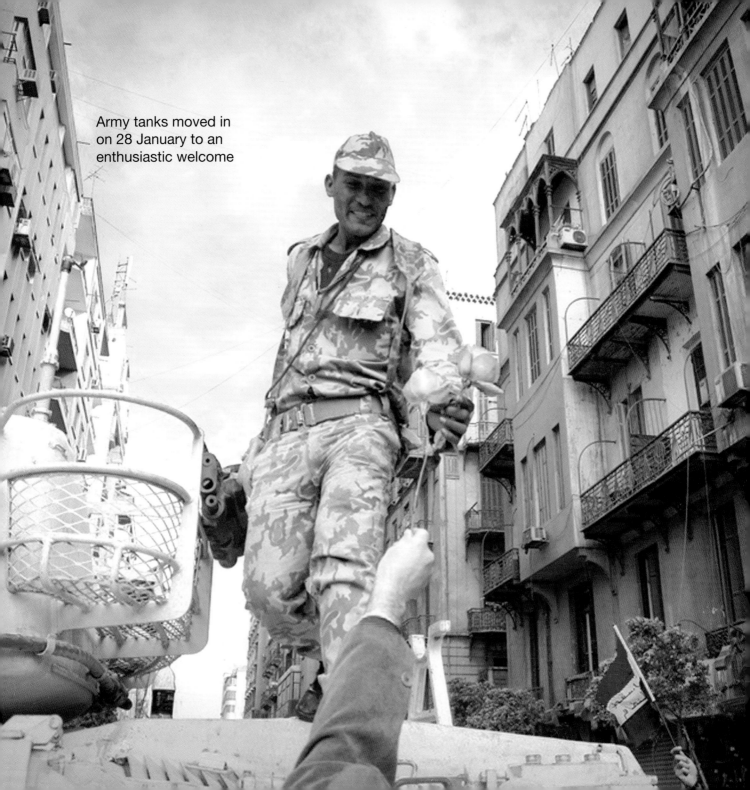

Army tanks moved in
on 28 January to an
enthusiastic welcome

I don't want to be another Khaled Said

On 6 June, 2010, a 28 year-old Alexandrian, Khaled Said, was dragged from an internet café in broad daylight and beaten to death by plainclothes police, sparking national outrage. The Facebook page "We Are All Khaled Said" set up by Google executive Wael Ghoneim was a turning point in the social media's rallying of anti-government activism.

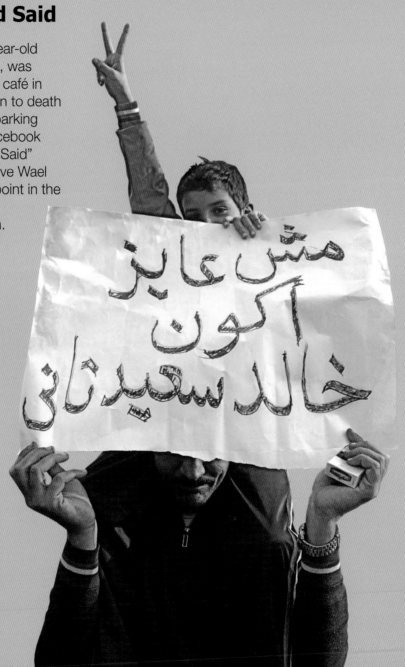

مش عايز اكون خالد سعيد تانى

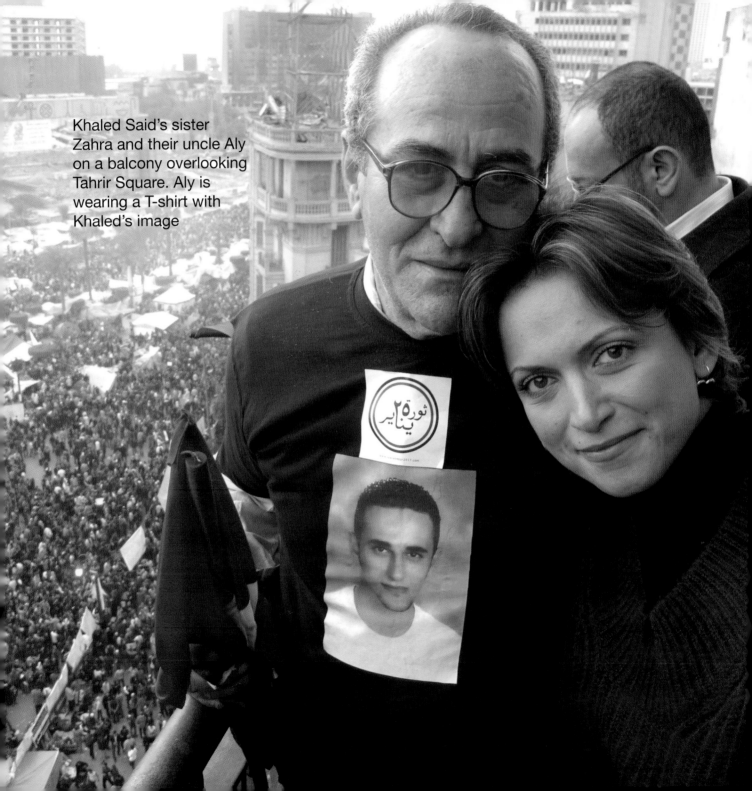

Khaled Said's sister Zahra and their uncle Aly on a balcony overlooking Tahrir Square. Aly is wearing a T-shirt with Khaled's image

"It is a message for all over the world

that the Egyptian people doesn't afraid from death and we are ready. We came here since 25 of January, supporting our sons. They started the revolution and we are supporting them. If we don't catch what we need, we are looking for the death.
WE ARE NOT AFRAID."

http://www.youtube.com/watch?v=12c3zl2PylQ

(spoken by the second man from the right)

THIS IS MY SHROUD, FOR EGYPT
Wearing makeshift shrouds, these men show their willingness to die for freedom

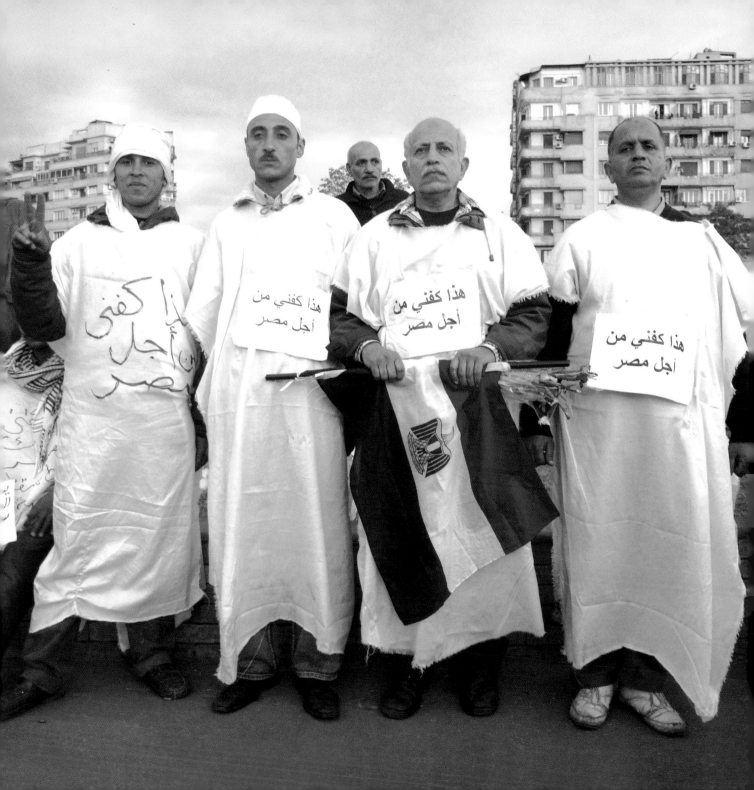

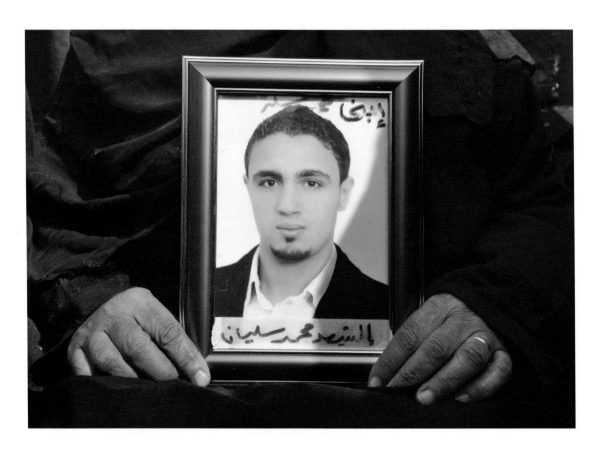

My son the martyr,
Mohamed Soliman

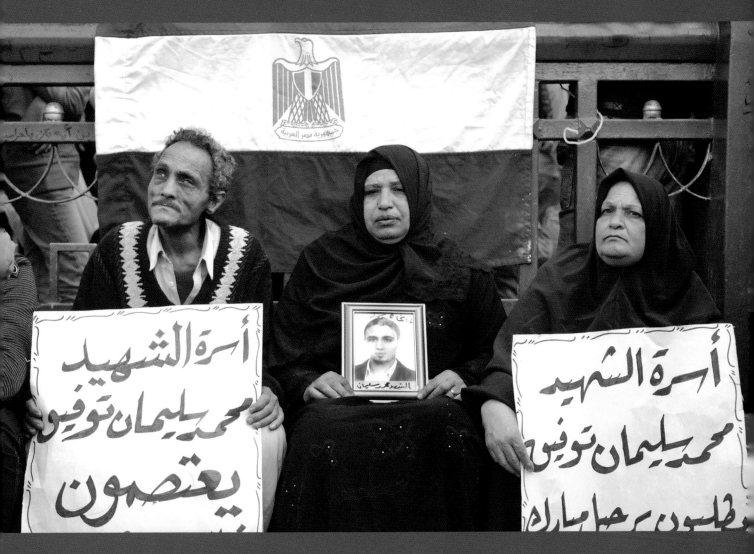

The family of martyr
Mohamed Soliman protest

The family of martyr Mohamed
Soliman demand Mubarak **GO**

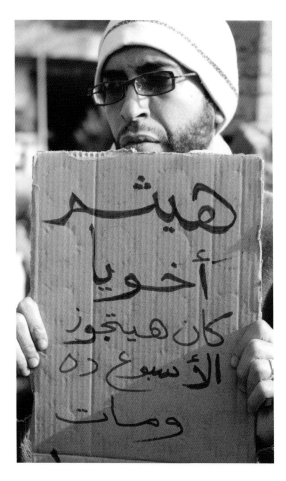

Haytham, my brother, was getting married this week...and died

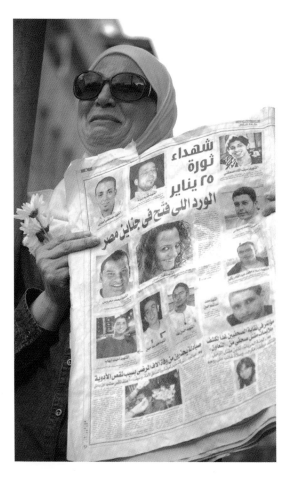

This weeping woman is holding up a newspaper with images of protesters killed by security forces; her son is one of them

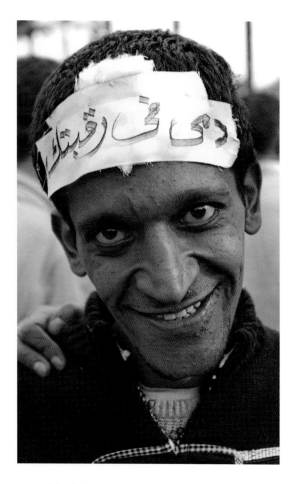

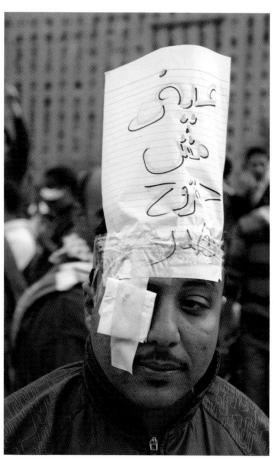

My blood is on your conscience

My eye won't be lost in vain

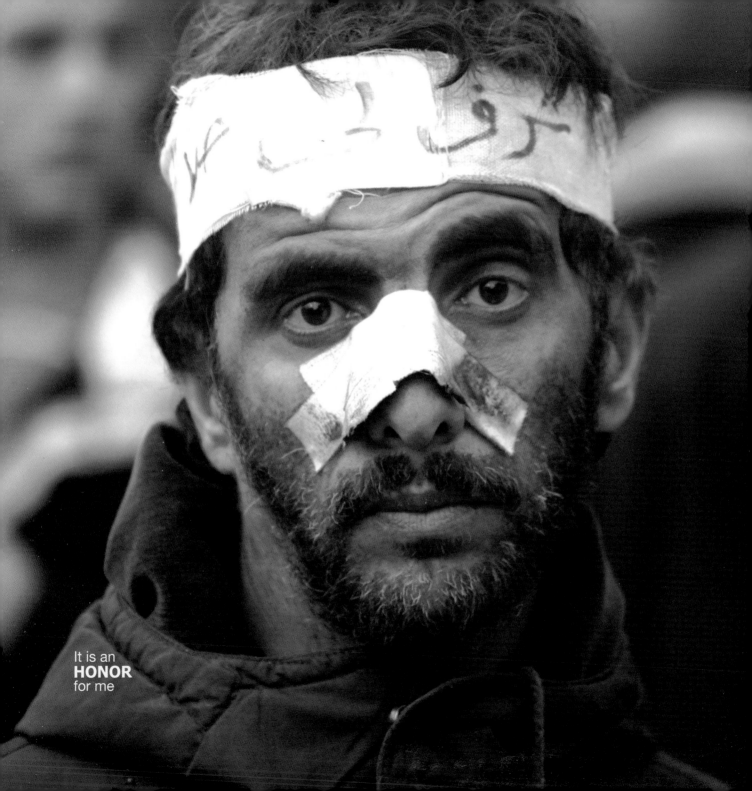

It is an
HONOR
for me

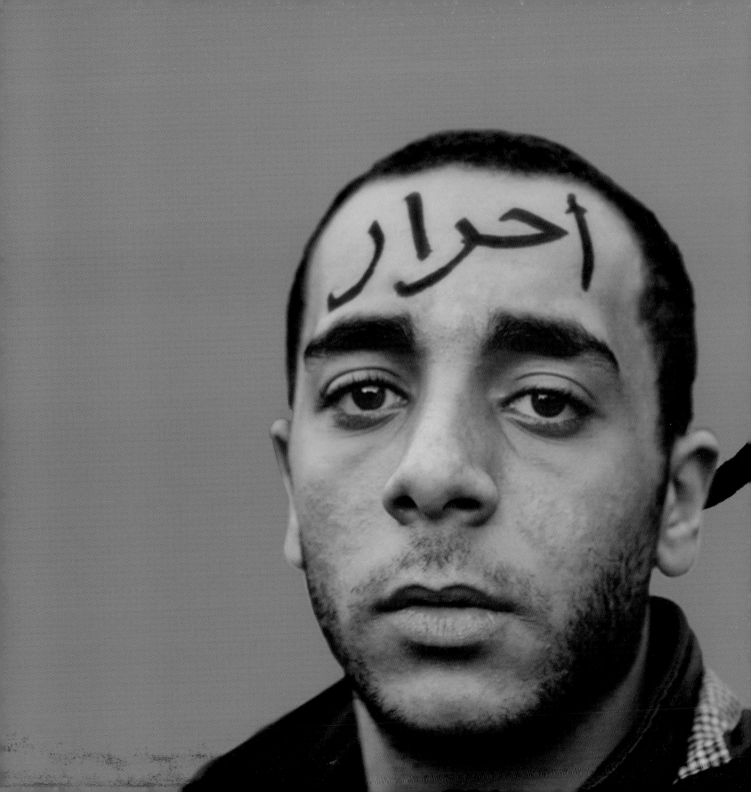

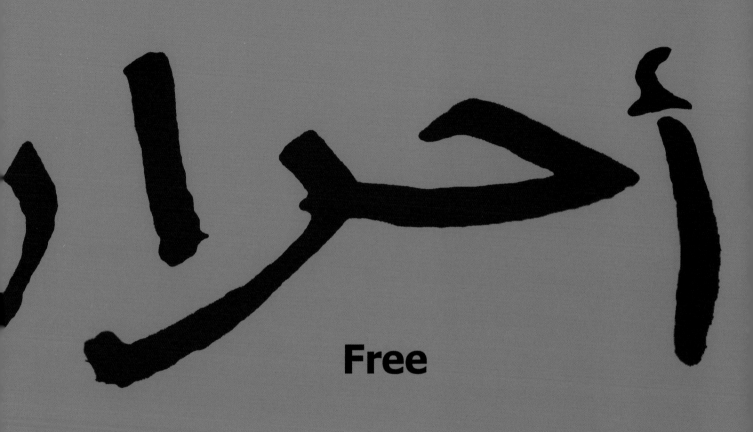

Free

Protesters stayed in the square
day after day; here they are facing
a makeshift stage

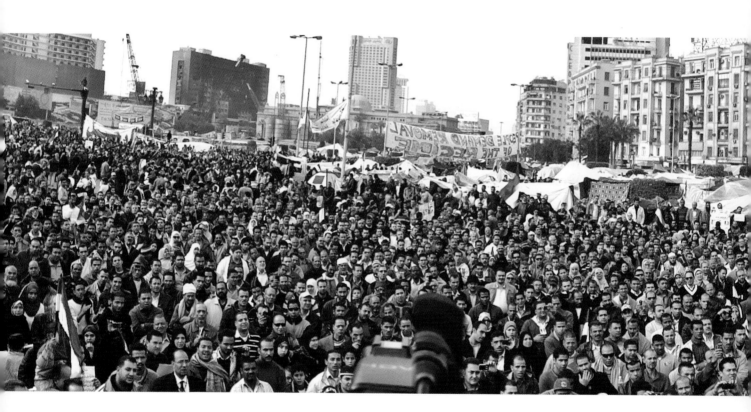

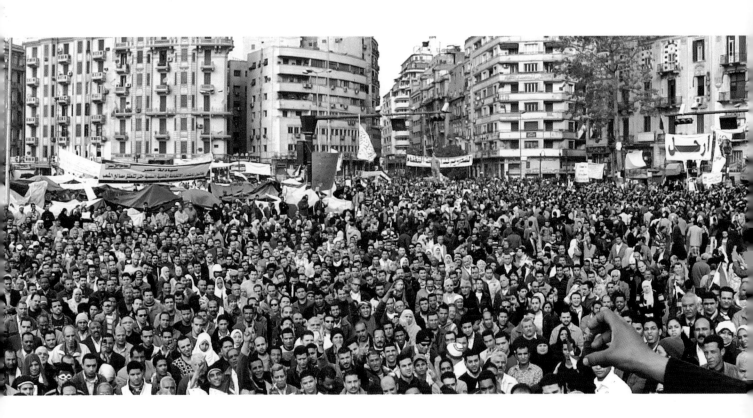

35

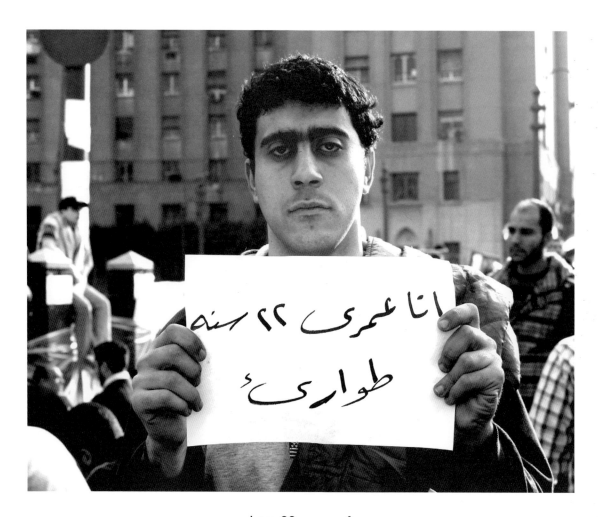

I am 22 years of
emergency rule old

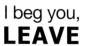

I beg you,
LEAVE

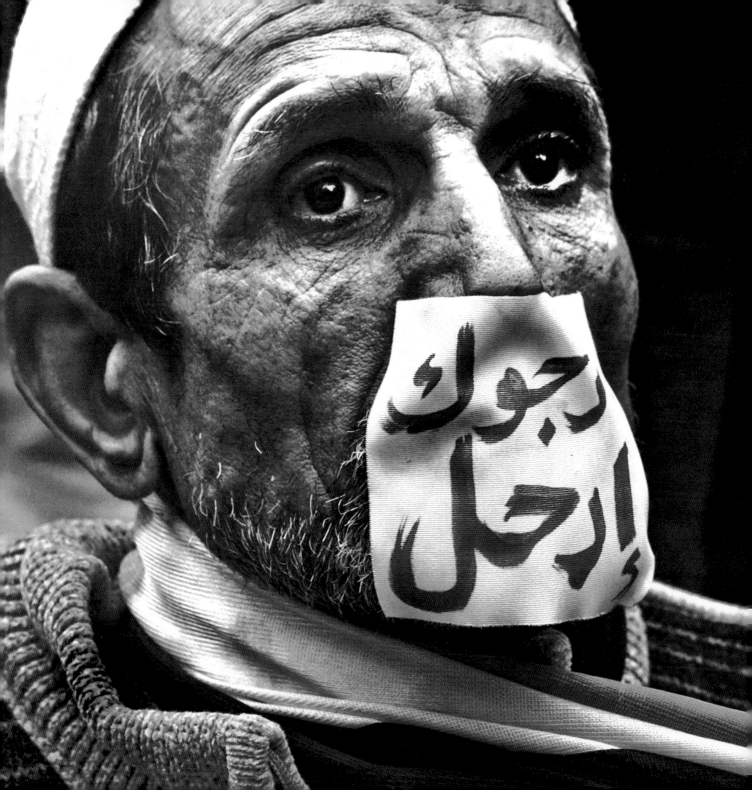

AMERICA, SHOULD
SUPPORT THE People
NOT THE tyrant

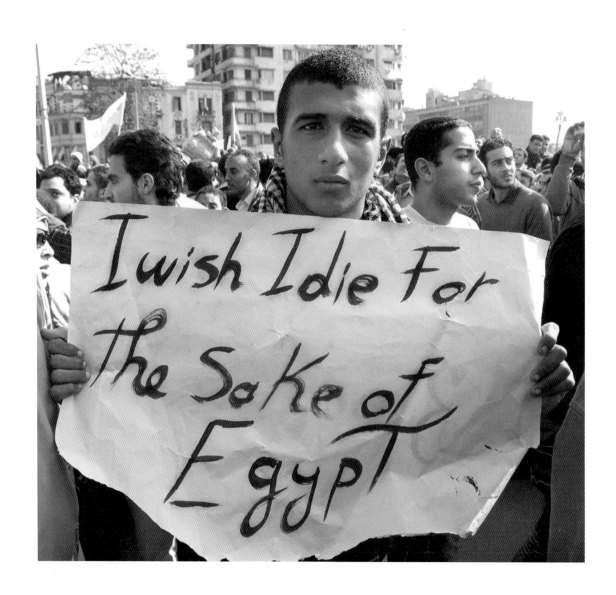

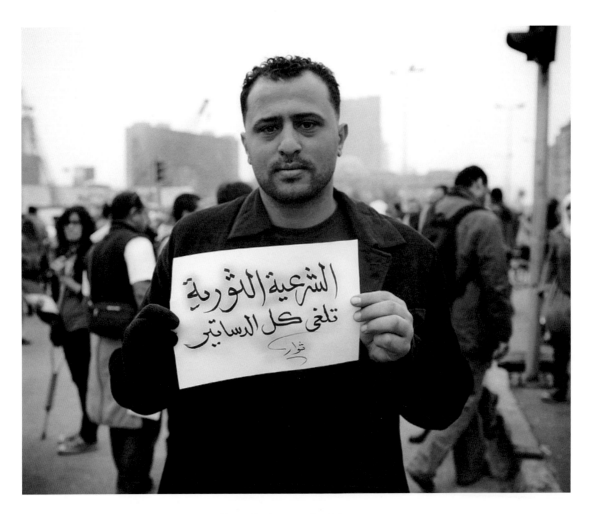

Revolutionary legitimacy
cancels all constitutions

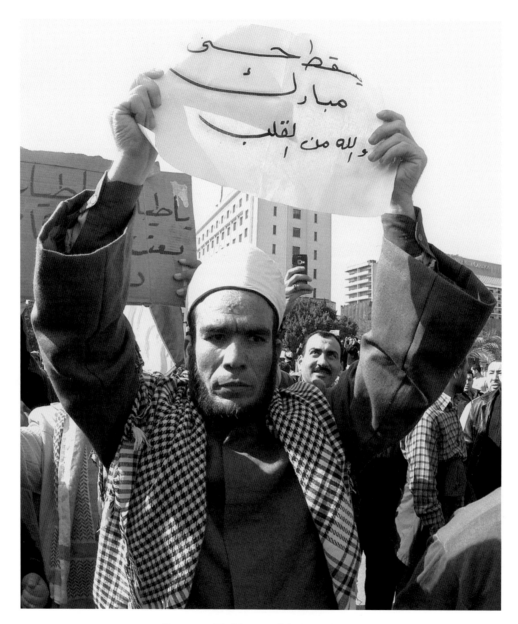

Down with Hosny Mubarak by
God, from the heart

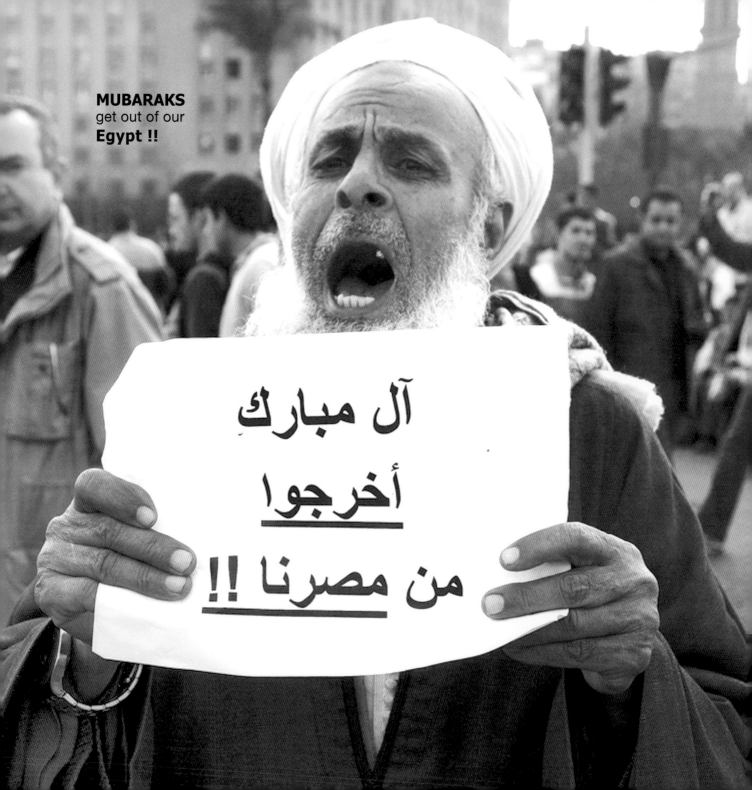

MUBARAKS
get out of our
Egypt !!

آل مبارك
أخرجوا
من مصرنا !!

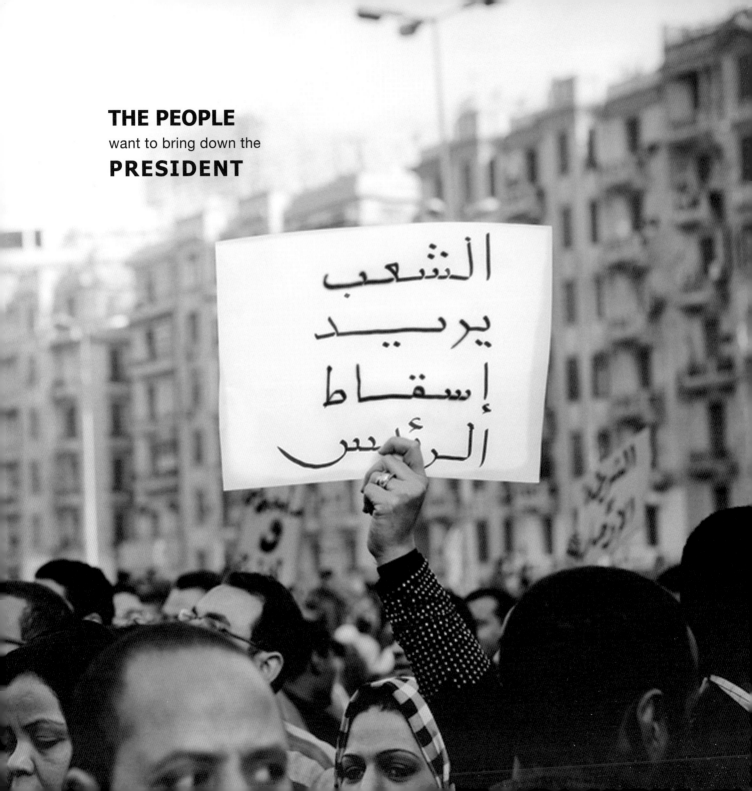

THE PEOPLE
want to bring down the
PRESIDENT

الشــعب
يريــد
إسقاط
الرئيس

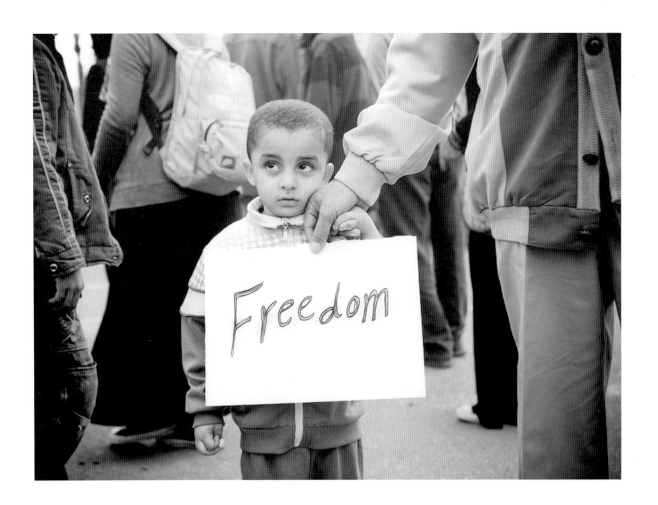

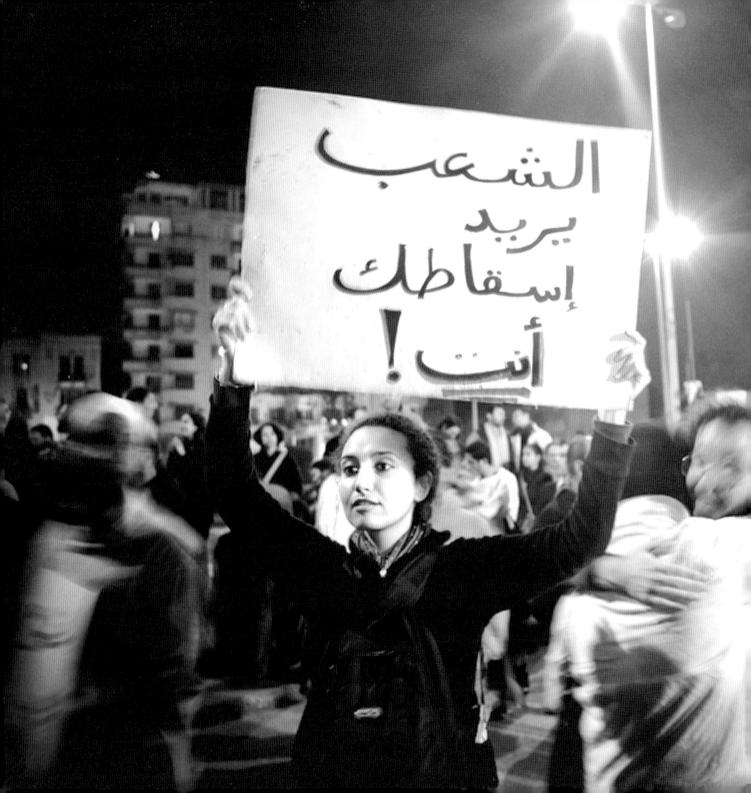

THE PEOPLE
WANT TO BRING
YOU DOWN !

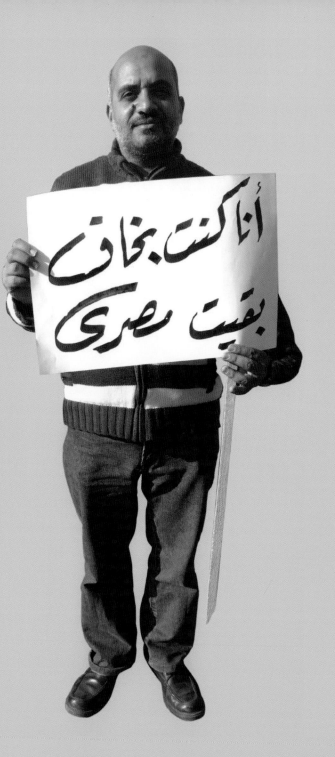

أنا كنت بخاف
بقيت مصري

I used to be
AFRAID...
I became
EGYPTIAN

Protestors
praying in
the Square

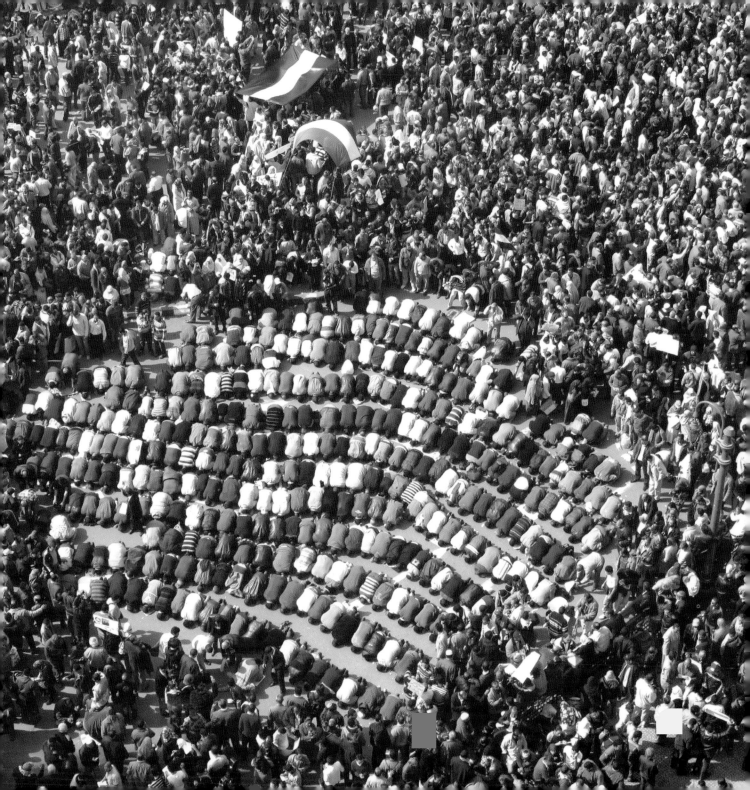

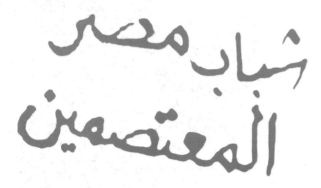

شباب مصر
المعتصمين

OUR DEMANDS

Overthrow of the president

Dissolution of the People's Assembly and the Shura Council

End of the state of emergency

Formation of a national unity transitional government

An elected parliament that will amend the constitution for presidential elections

Immediate trial of those responsible for the deaths of the martyrs of the revolution

Speedy corruption trials of those responsible for stealing the nation's wealth

Egypt's youth

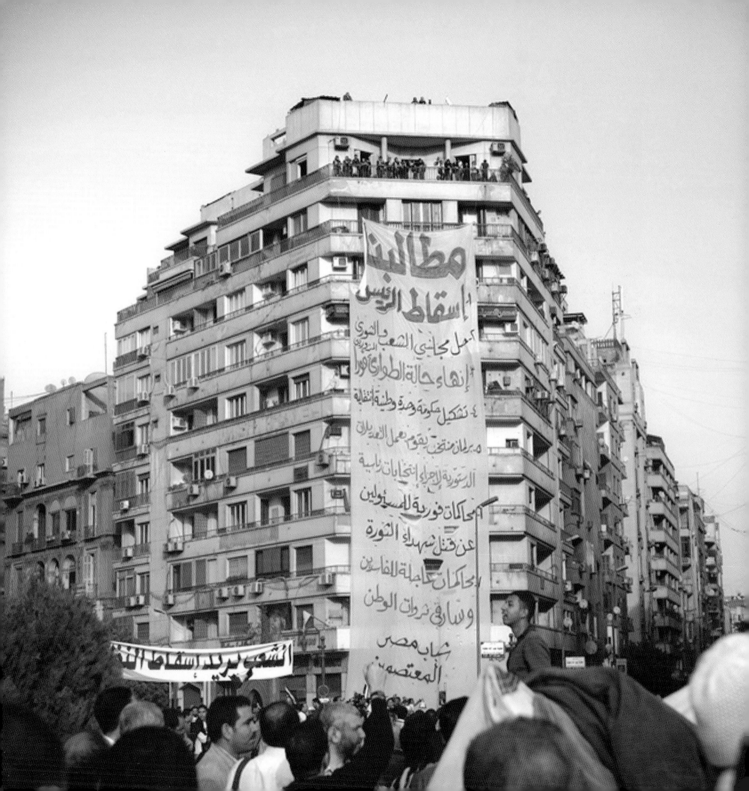

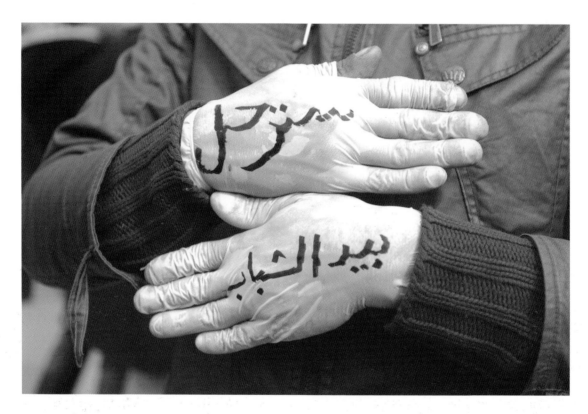

You will leave by the hands of the youth

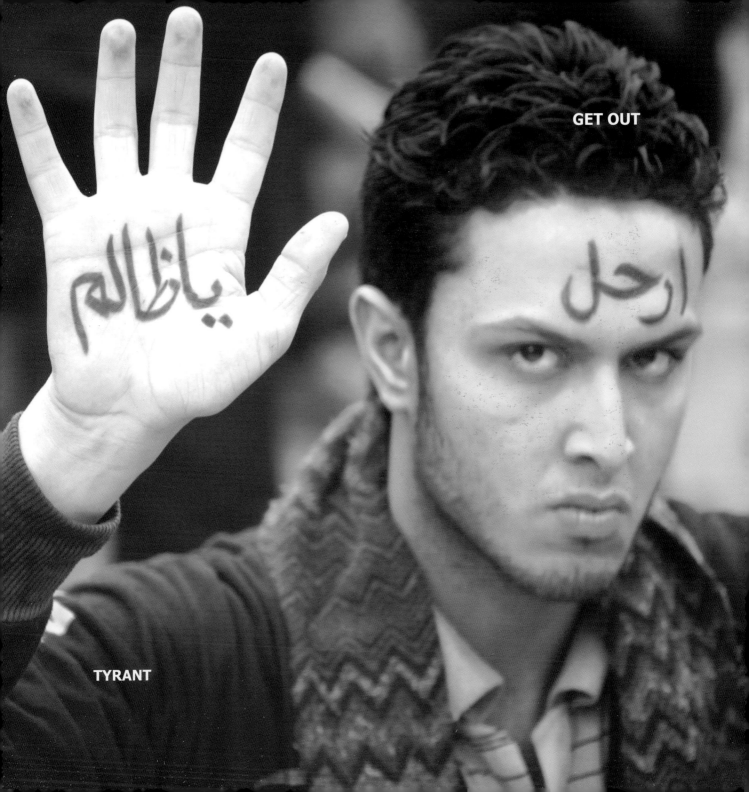

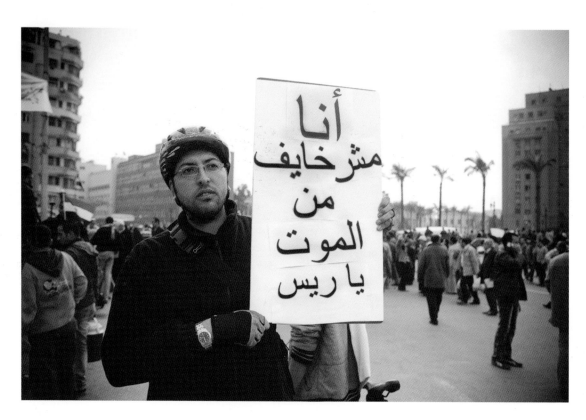

I'm not afraid of
dying, Mr. President

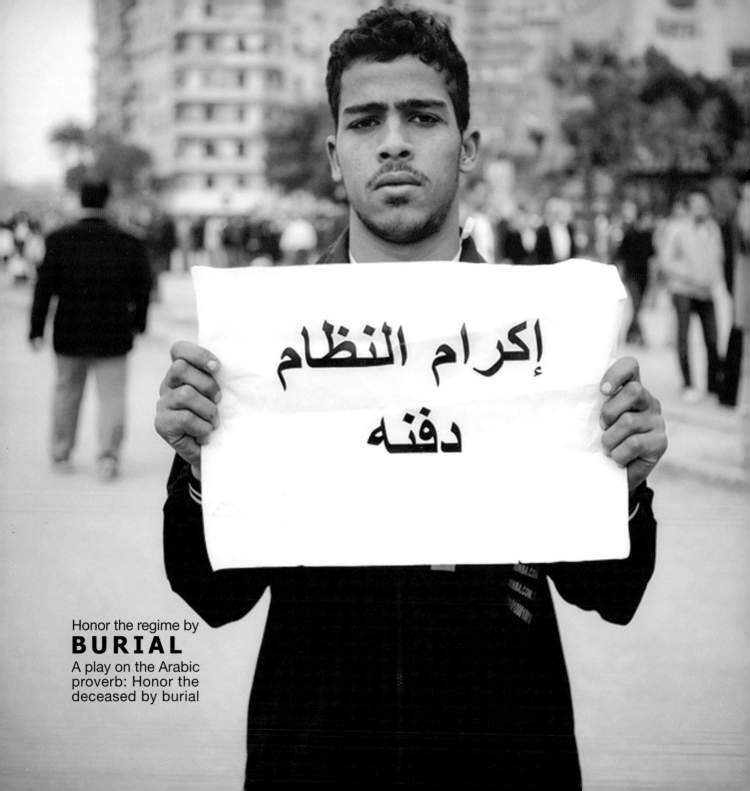

إكرام النظام دفنه

Honor the regime by
BURIAL
A play on the Arabic
proverb: Honor the
deceased by burial

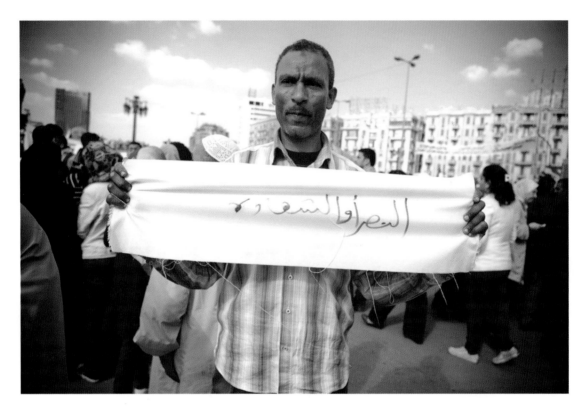

Protesters made signs of whatever came to hand. This man has written VICTORY OR DEATH on a piece of cloth

This man has used the sole of his shoe as his sign, stuck on top of a broom; showing the sole of one's shoe is in itself insulting

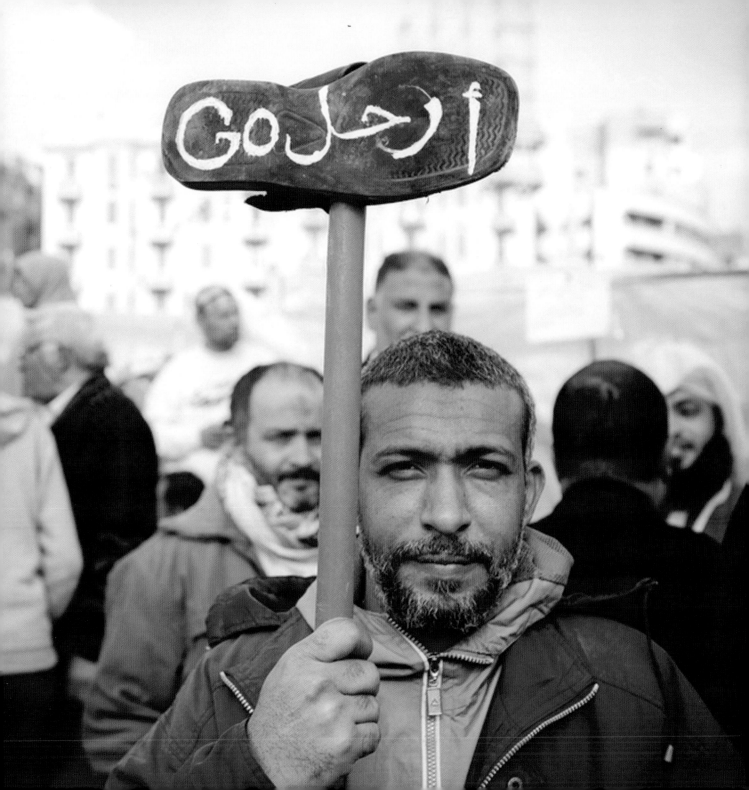

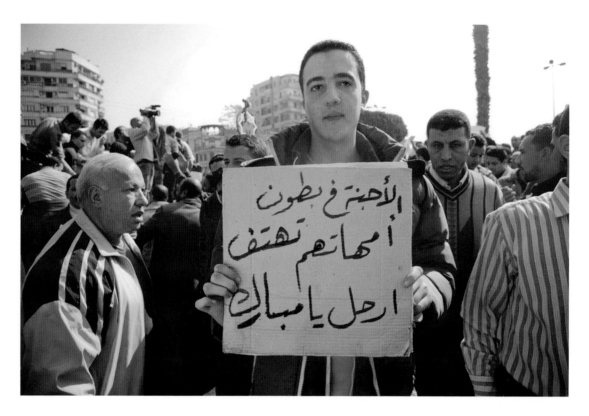

Babies in the womb cry
LEAVE MUBARAK

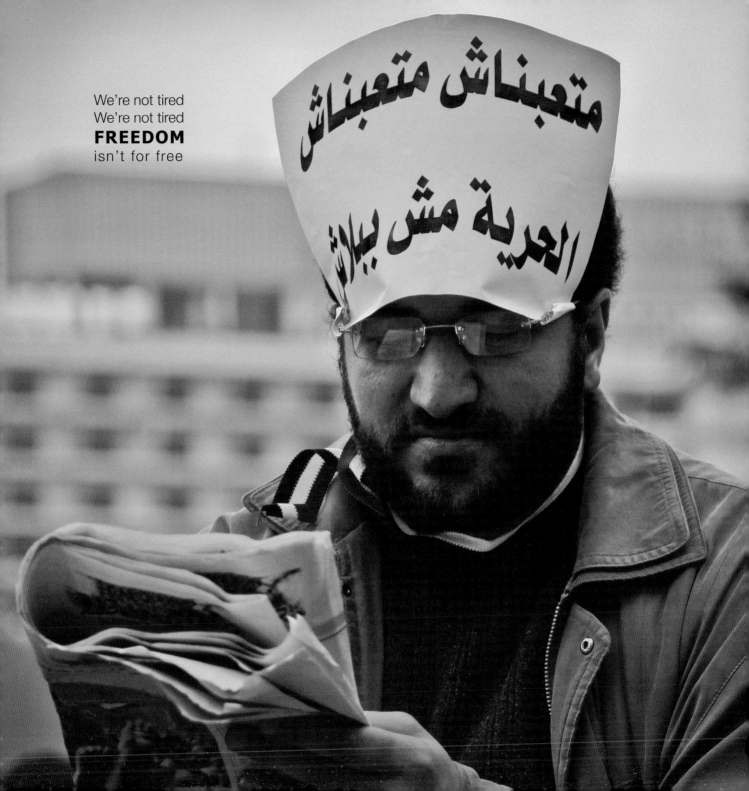

We're not tired
We're not tired
FREEDOM
isn't for free

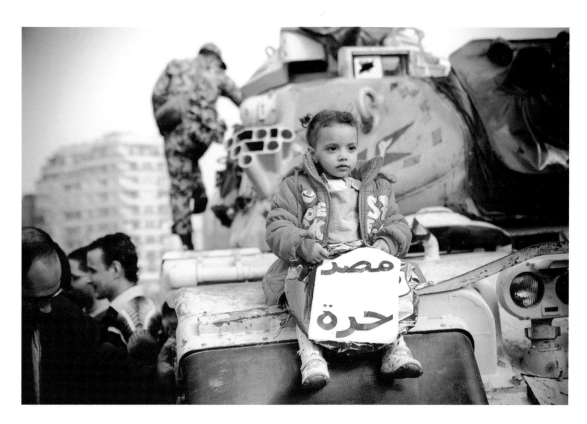

FREE EGYPT

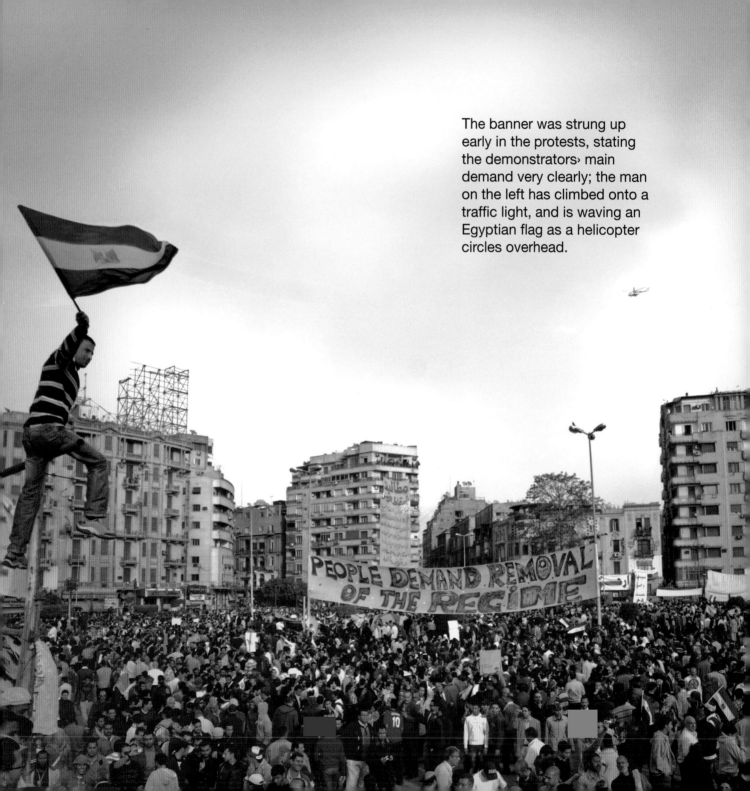

The banner was strung up early in the protests, stating the demonstrators› main demand very clearly; the man on the left has climbed onto a traffic light, and is waving an Egyptian flag as a helicopter circles overhead.

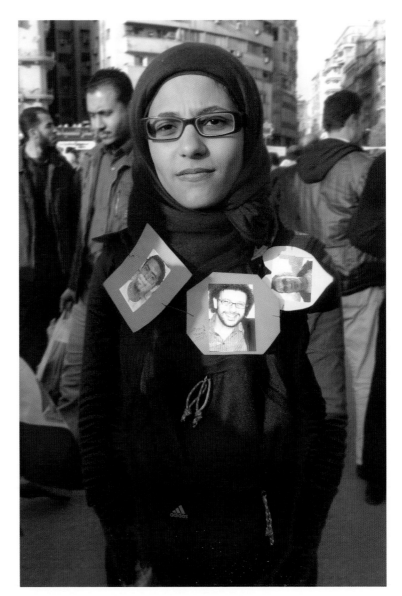

This young woman has strung together a necklace made of photos of protesters killed by security forces; the central photo shows Ahmed Bassiouny, a 33 year-old artist, shot while filming struggles between the demonstrators and the police.

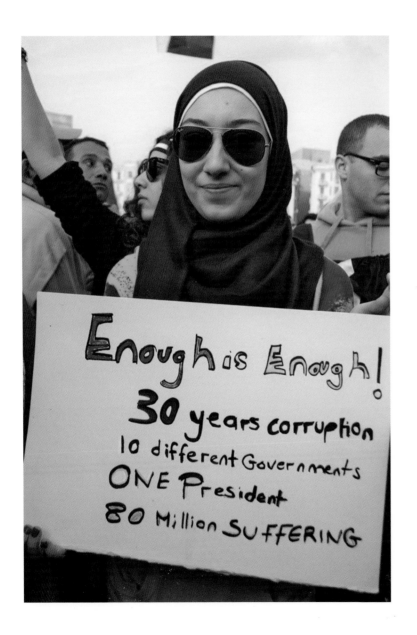

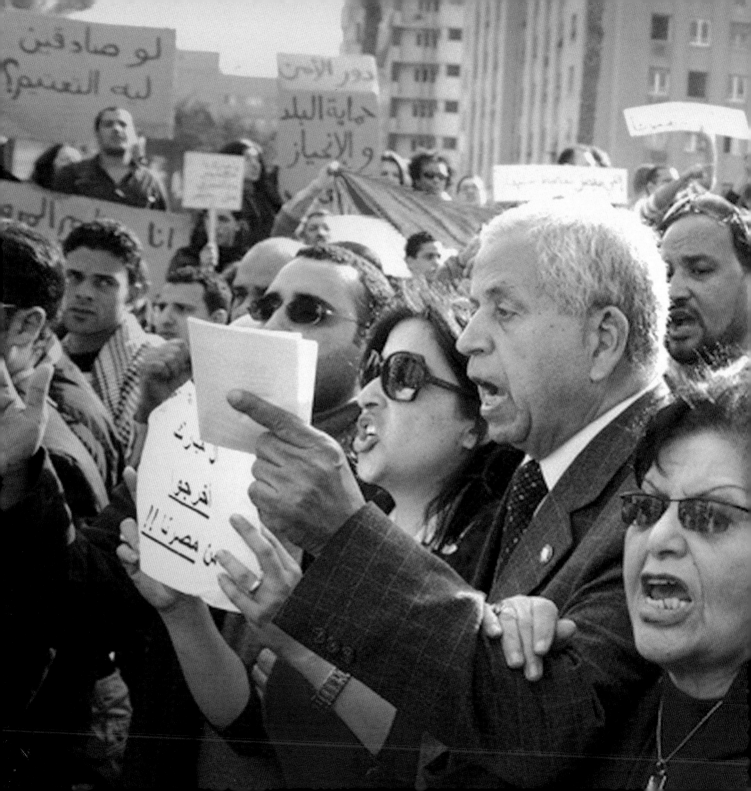

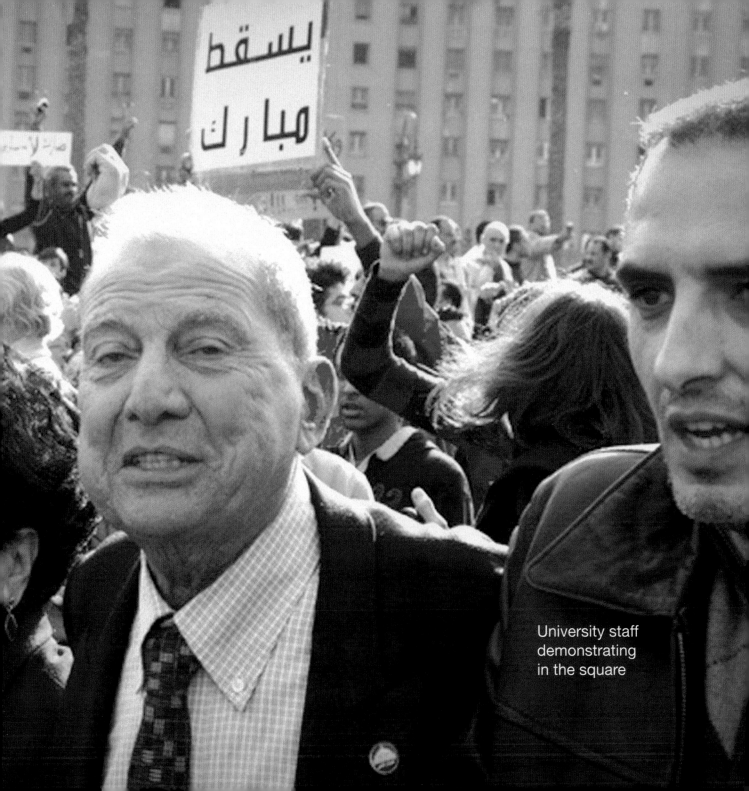

University staff
demonstrating
in the square

This boy has painted
his face the colors of
the Egyptian flag

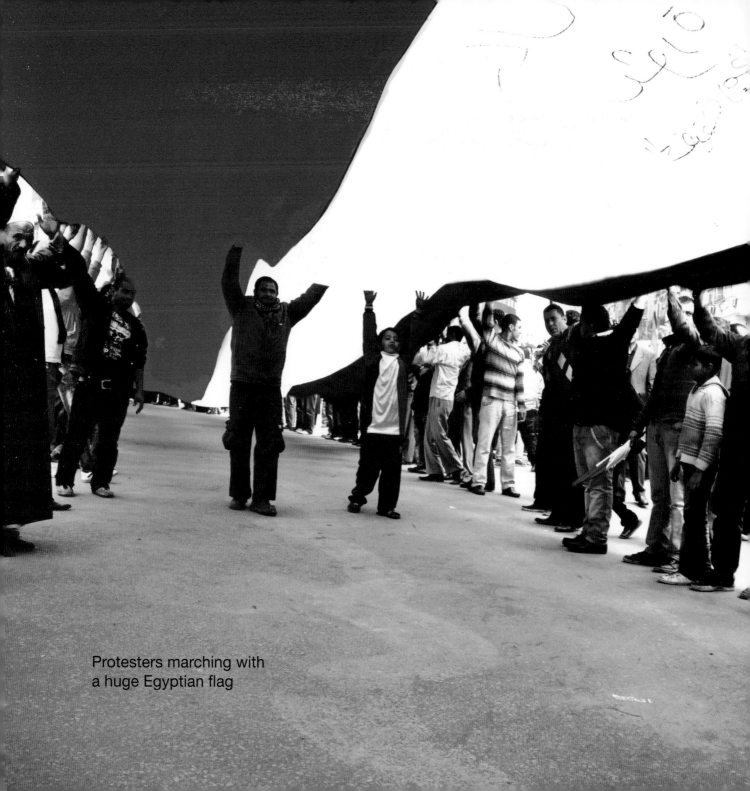

Protesters marching with
a huge Egyptian flag

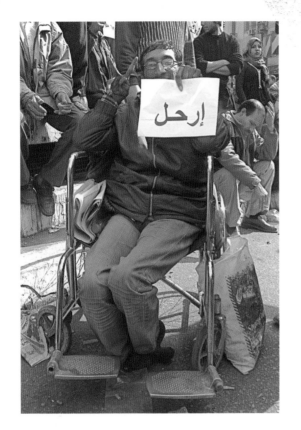 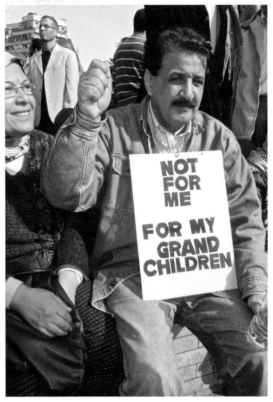

LEAVE

Ahmed was carried
into the square every
day in his wheelchair

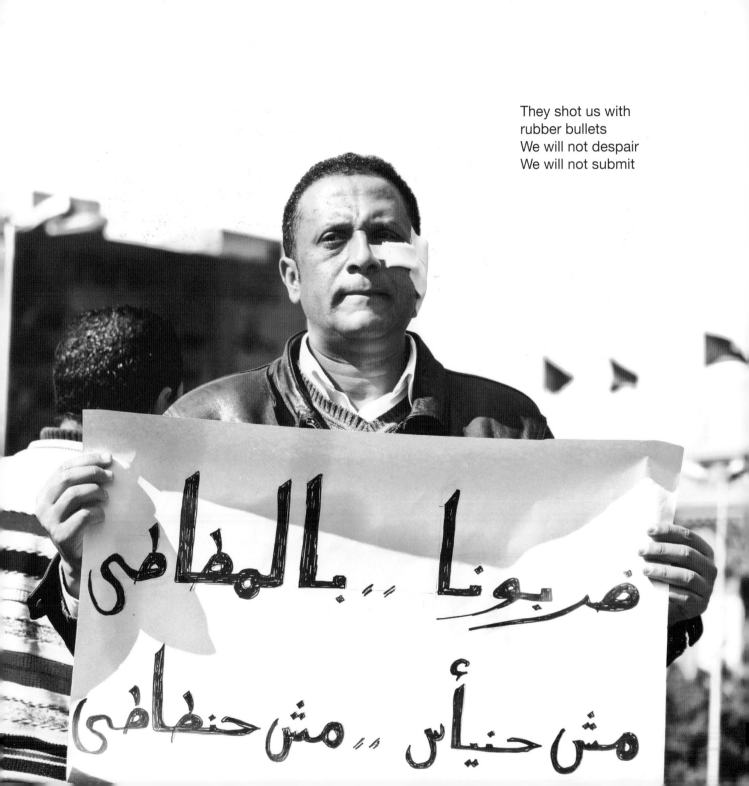

They shot us with
rubber bullets
We will not despair
We will not submit

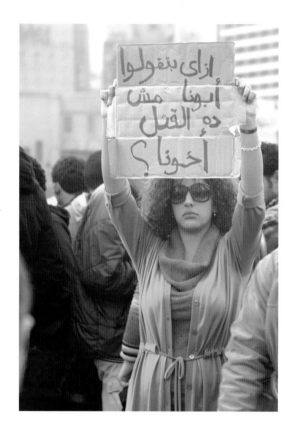
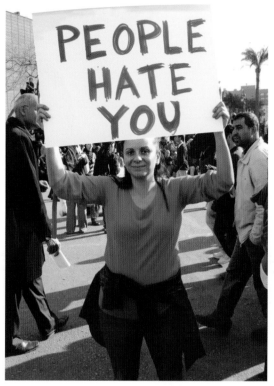

How can they say he's
our father?
Isn't he the one who killed
our brother?

Forgive me Lord,
I was afraid and silent

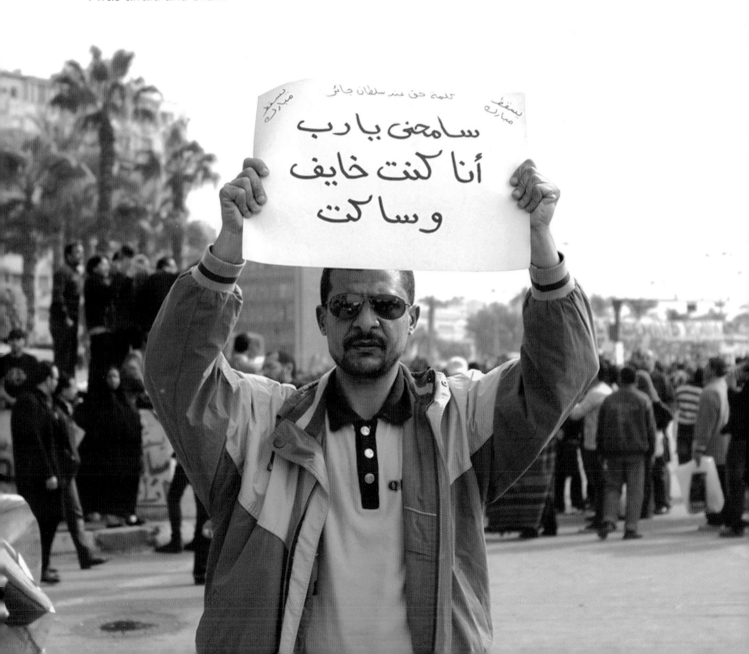

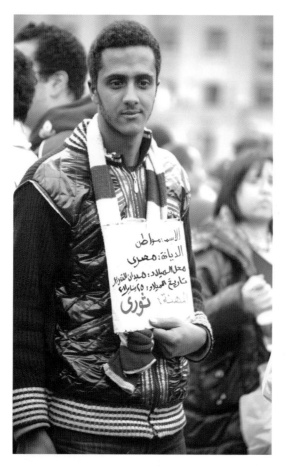

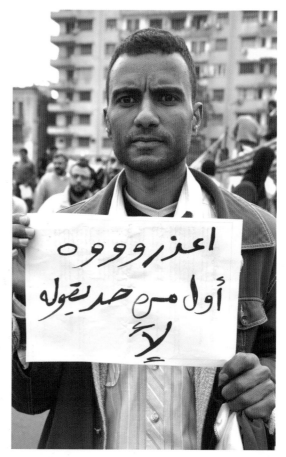

Name: Citizen
Religion: Egyptian
Place of birth: Tahrir square
Date of birth: 25 January, 2011
Occupation: Revolutionary

Forgive him, no one's said NO to him before

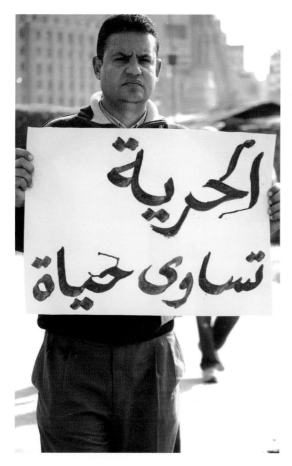

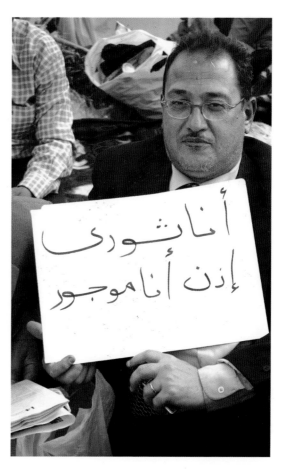

Freedom equals life

I'm a revolutionary therefore I am

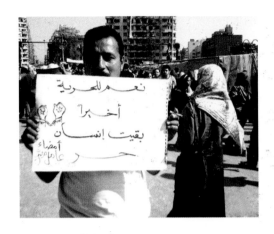

Yes to liberty
at last
I'm a free human being

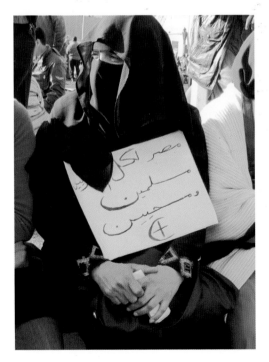

Egypt belongs to all Egyptians
Muslims and Christians

WE CAME
TO KISS
THE FEET OF THE
REVOLUTION'S
YOUTH

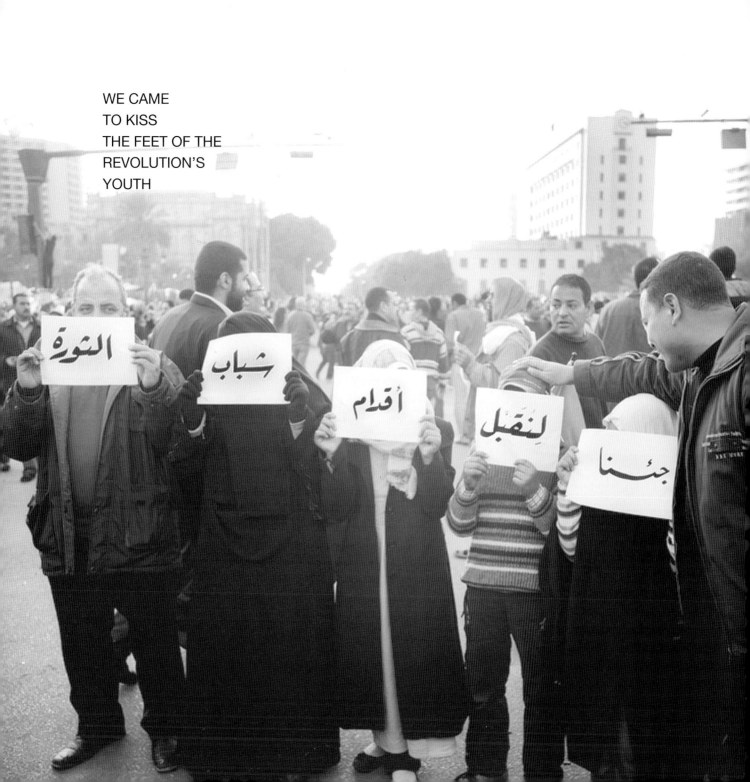

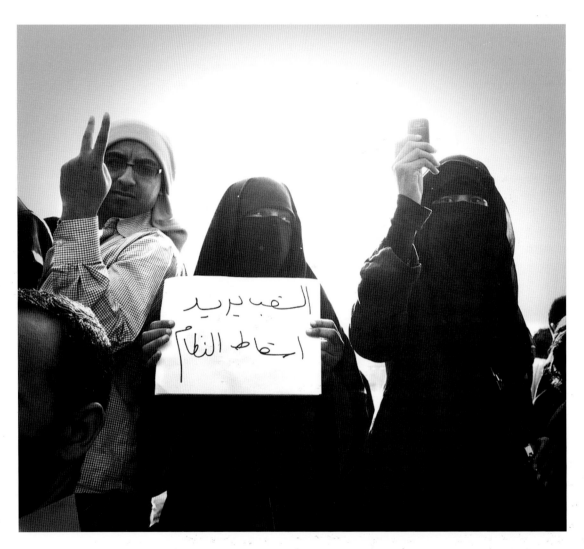

The people want the regime brought down

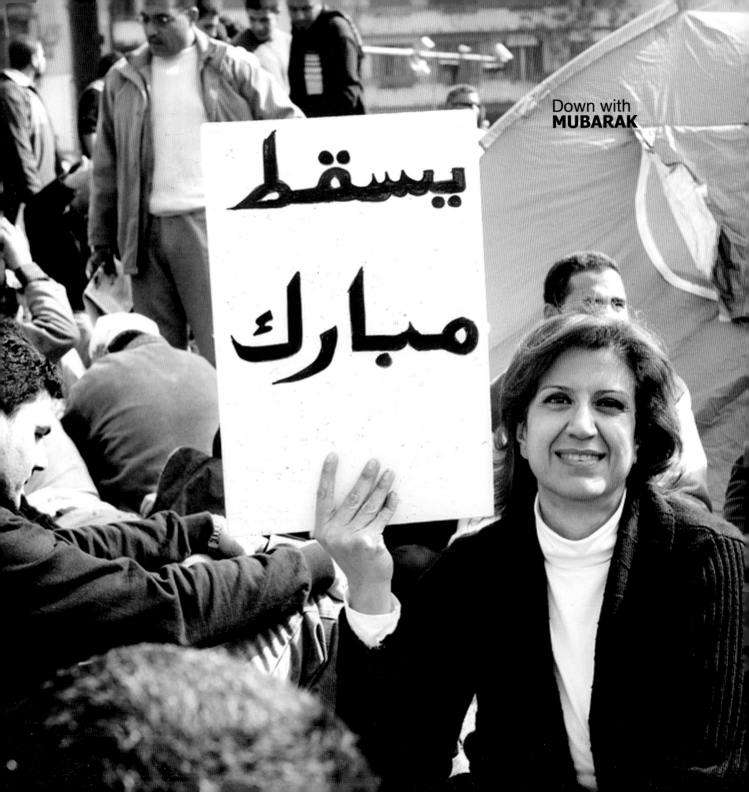

يسقط
مبارك

Down with
MUBARAK

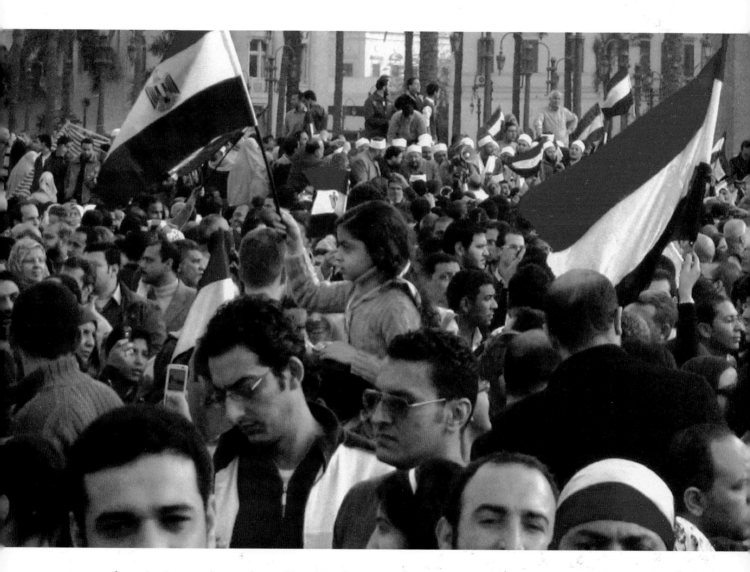

A protester carries a sign with a Muslim crescent
and a Christian cross, symbolizing interfaith unity

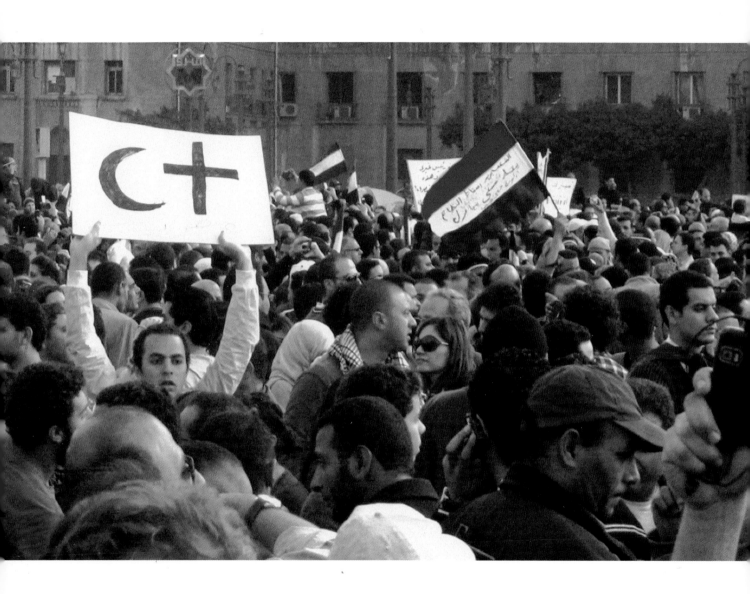

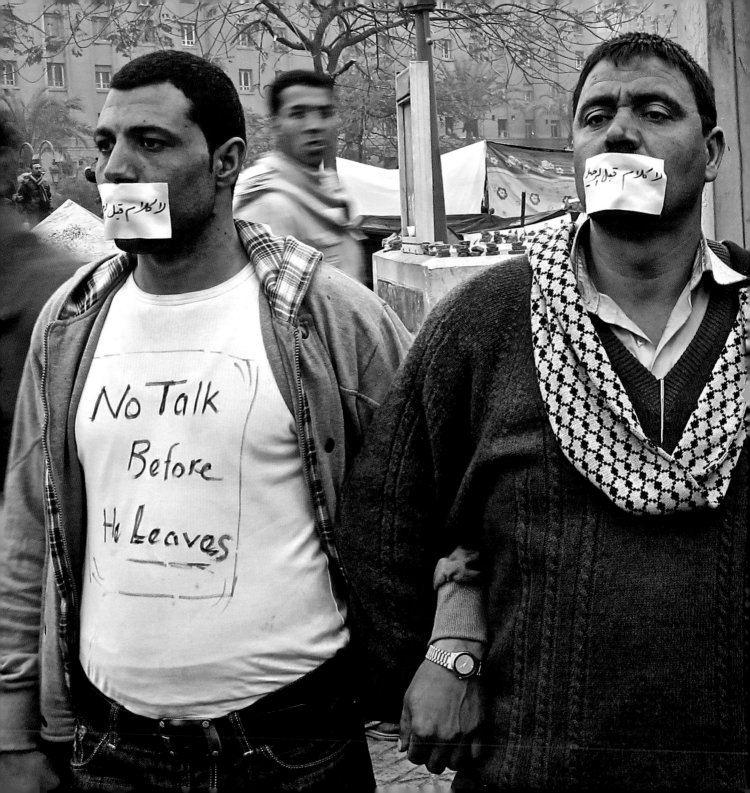

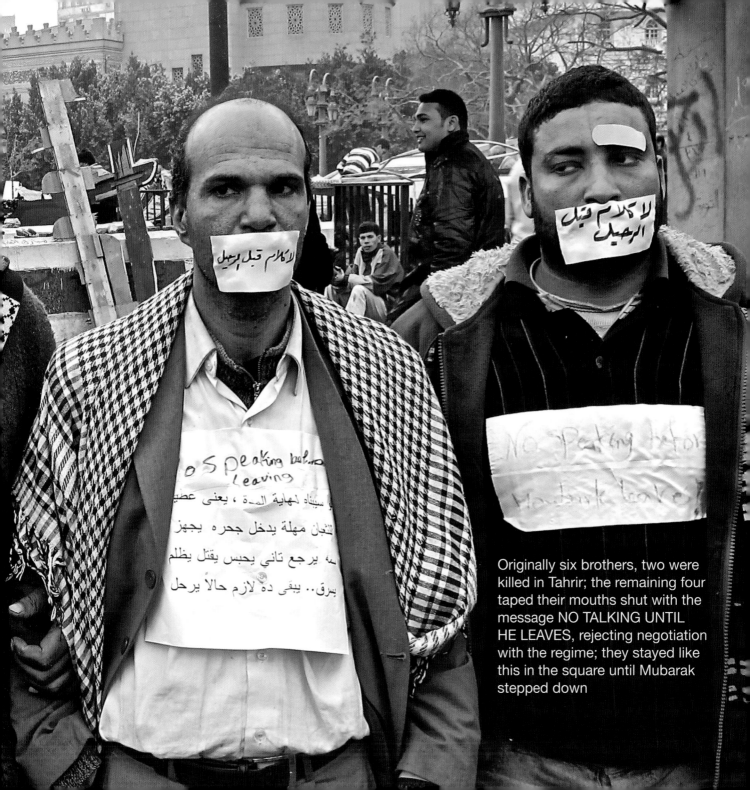

Originally six brothers, two were killed in Tahrir; the remaining four taped their mouths shut with the message NO TALKING UNTIL HE LEAVES, rejecting negotiation with the regime; they stayed like this in the square until Mubarak stepped down

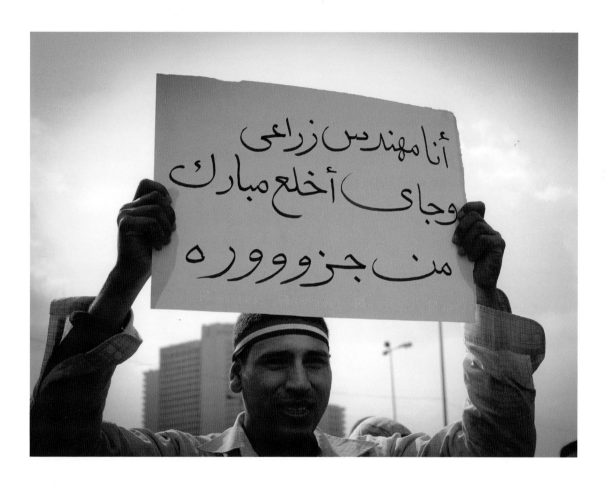

I'm an agricultural engineer
I've come to tear Mubarak out
by the ROOTS

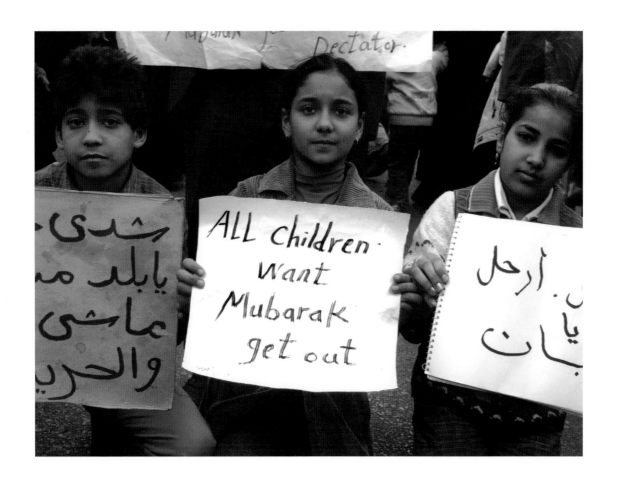

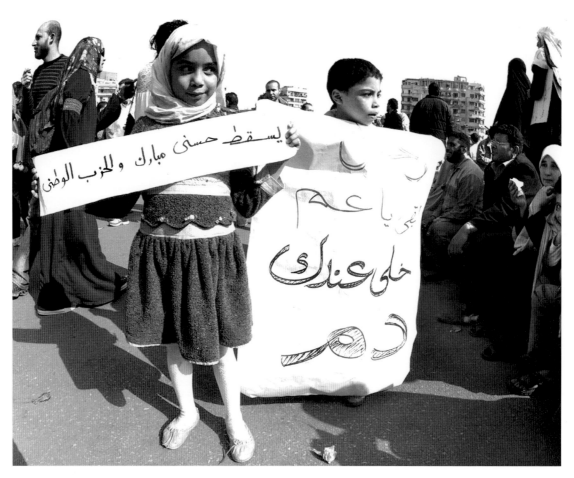

(The girl)
Down with Hosny Mubarak
and the National Democratic
Party

(The boy)
LEAVE already!
Show some feeling!

I understand
you and you
understand me
You're not leaving
And we're not
leaving
LET"S SEE
Who's going to leave
signed The People

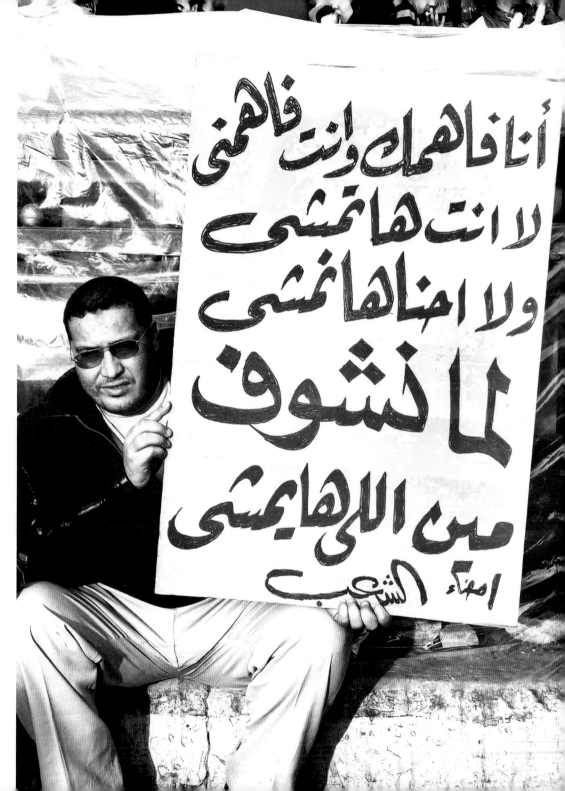

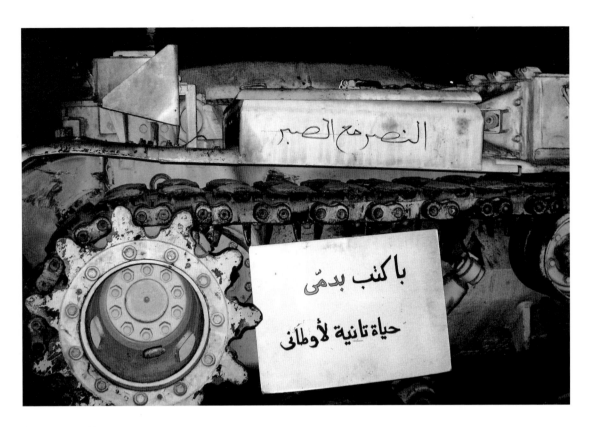

(on the tank)
Victory comes with
patience

(on the sign)
With my blood, I write
another life for my country

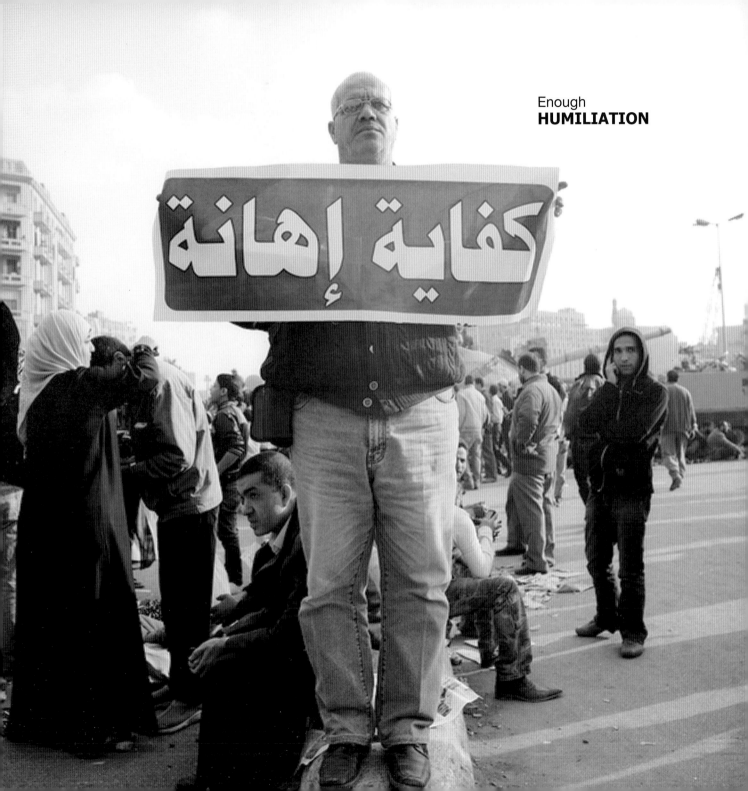

Enough
HUMILIATION

كفاية إهانة

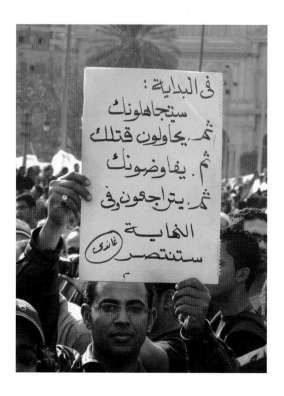

Two languages,
the same message from Gandhi

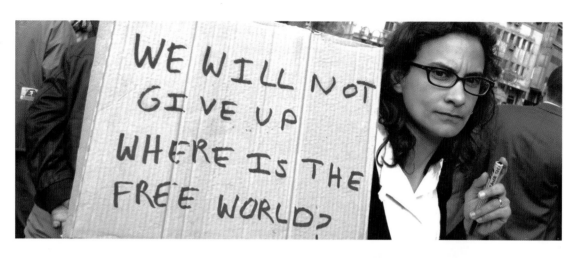

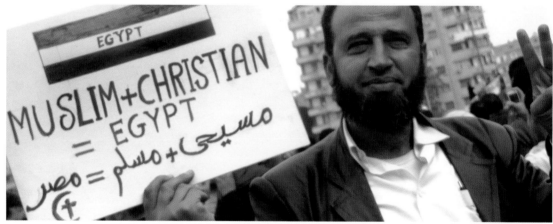

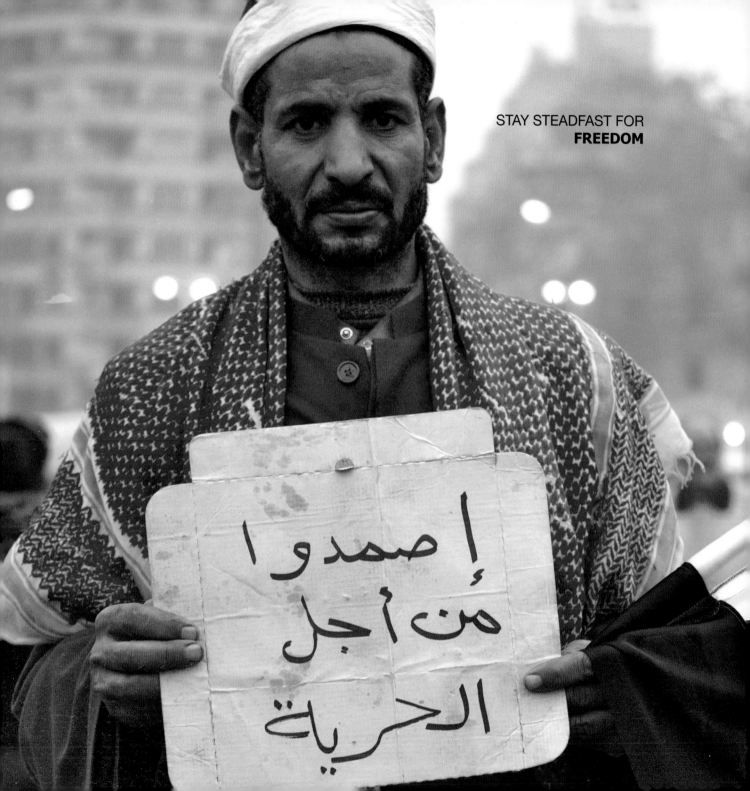

STAY STEADFAST FOR
FREEDOM

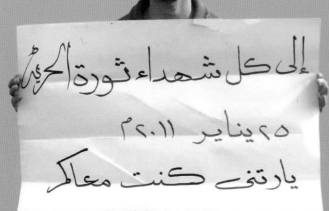

إلى كل شهداء ثورة الحرية
٢٥ يناير ٢٠١١م
يارتنى كنت معاكم

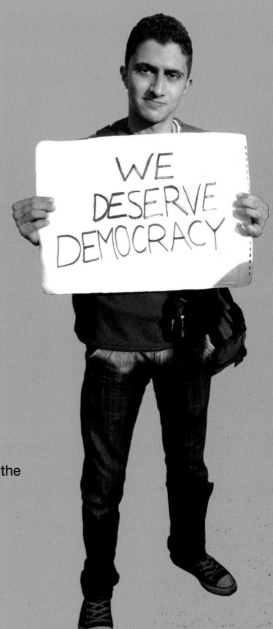

WE
DESERVE
DEMOCRACY

To all the martyrs of the
Freedom Revolution
25 January 2011
**I WISH I WERE
WITH YOU**

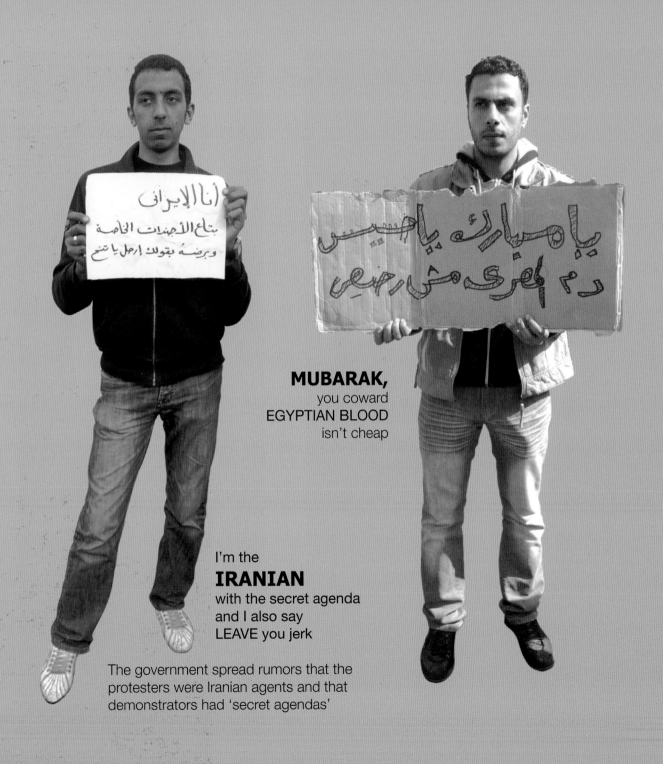

أنا الإيراني
بتاع الأجندات الخاصة
وبرضه بقولك إرحل يا سخيف

يا مبارك يا حسني
دم المصري مش رخيص

MUBARAK,
you coward
EGYPTIAN BLOOD
isn't cheap

I'm the
IRANIAN
with the secret agenda
and I also say
LEAVE you jerk

The government spread rumors that the
protesters were Iranian agents and that
demonstrators had 'secret agendas'

After a week with no
statement from Mubarak,
protesters laced their
determination with typically
scathing Egyptian wit

A week, Mr. President,
and not even a phone call?

In Tahrir even balloons
became signs; this one says
"I WON'T GO, HE GOES"

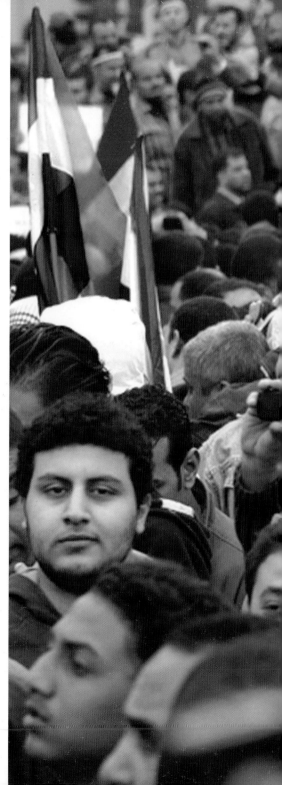

It's a difficult delivery
because the newborn's name is
FREEDOM

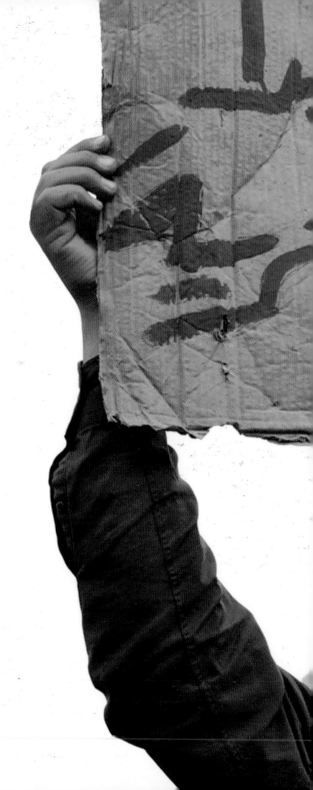

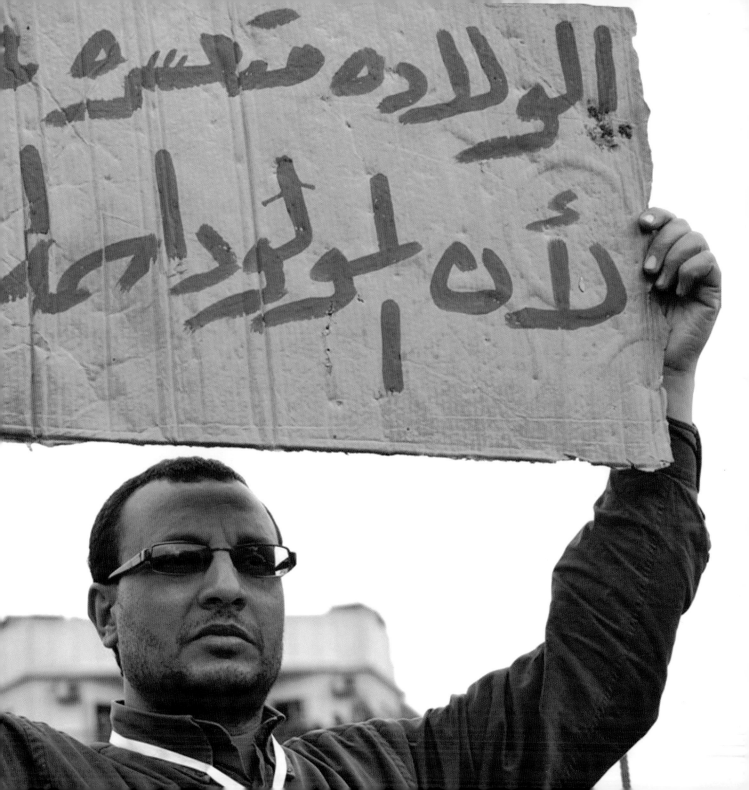

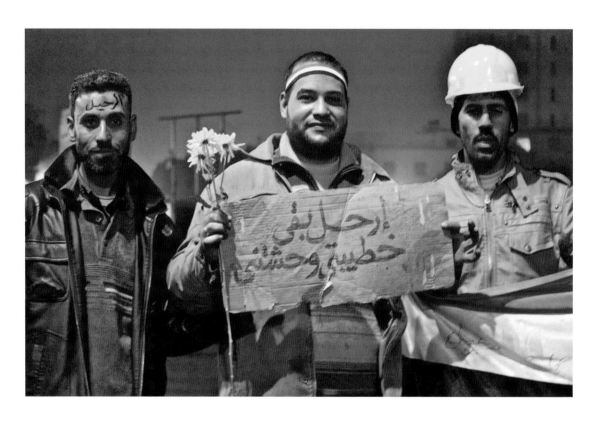

LEAVE ALREADY
I miss my fiancee

LEAVE
I MISS MY WIFE
I've been married for
20 days

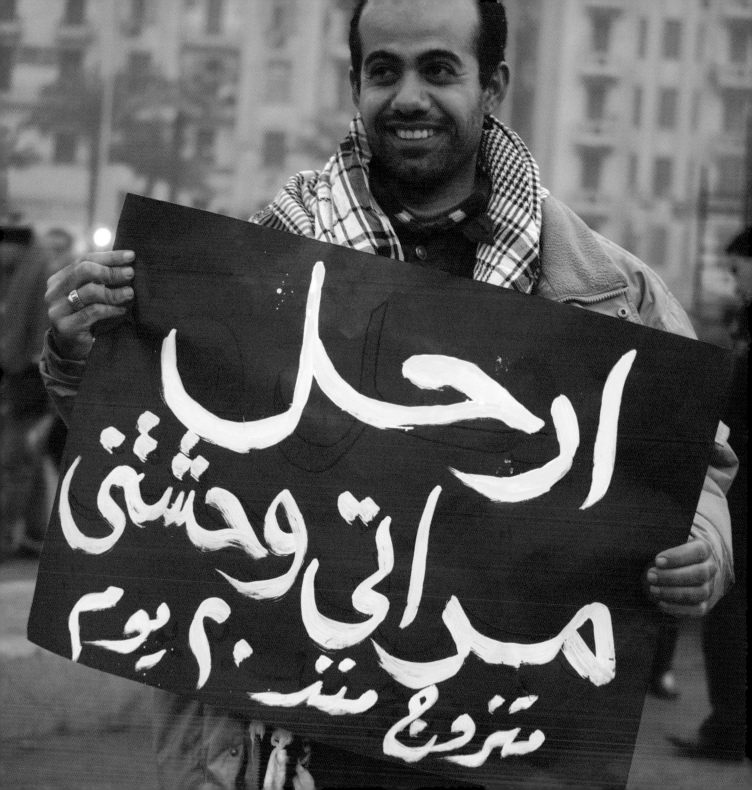

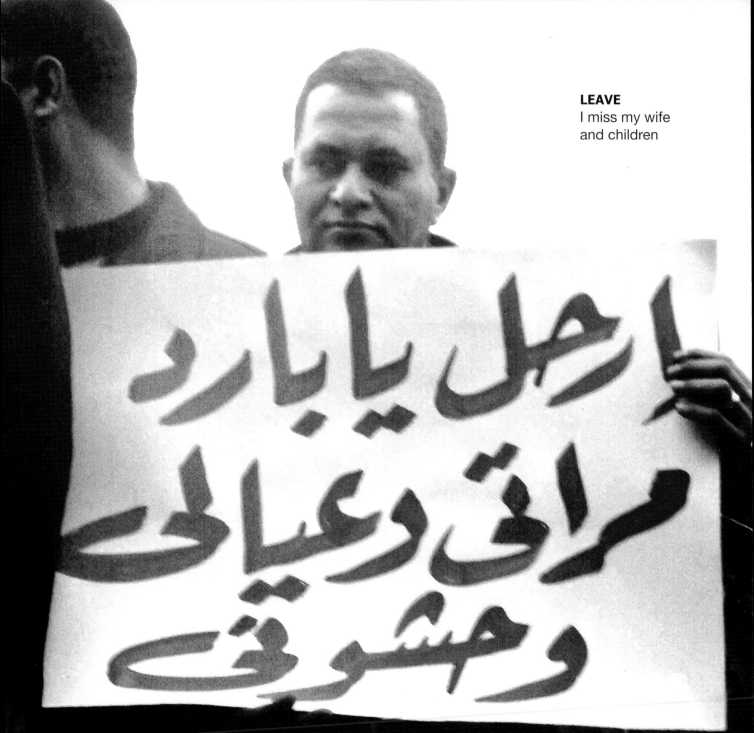

LEAVE
I miss my wife
and children

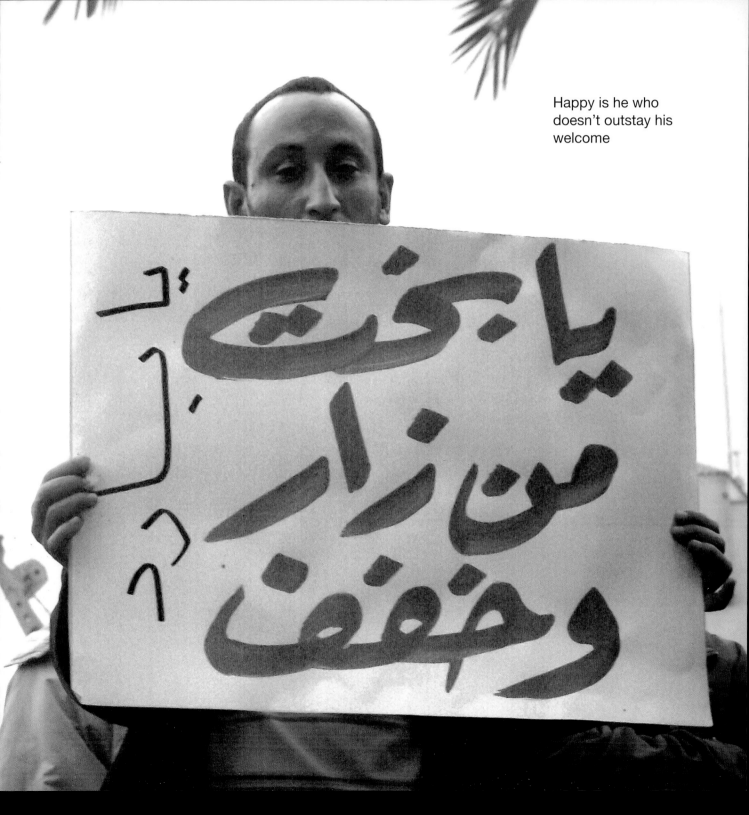

Happy is he who
doesn't outstay his
welcome

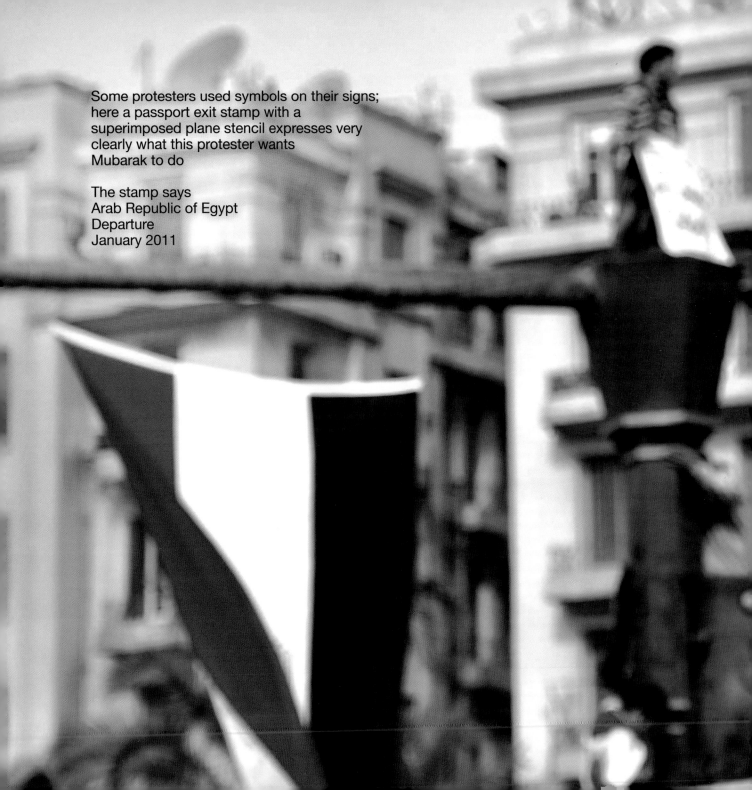

Some protesters used symbols on their signs;
here a passport exit stamp with a
superimposed plane stencil expresses very
clearly what this protester wants
Mubarak to do

The stamp says
Arab Republic of Egypt
Departure
January 2011

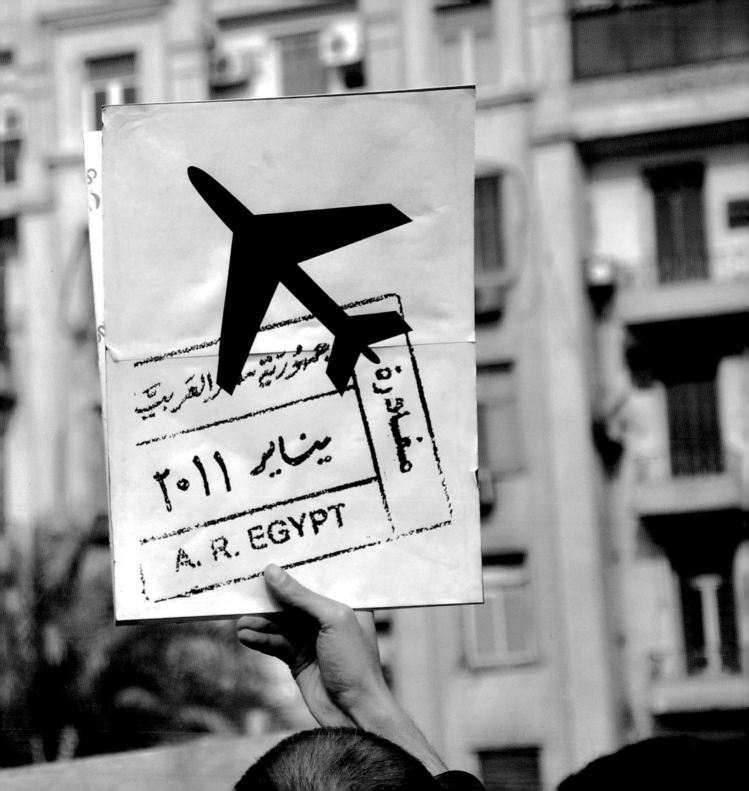

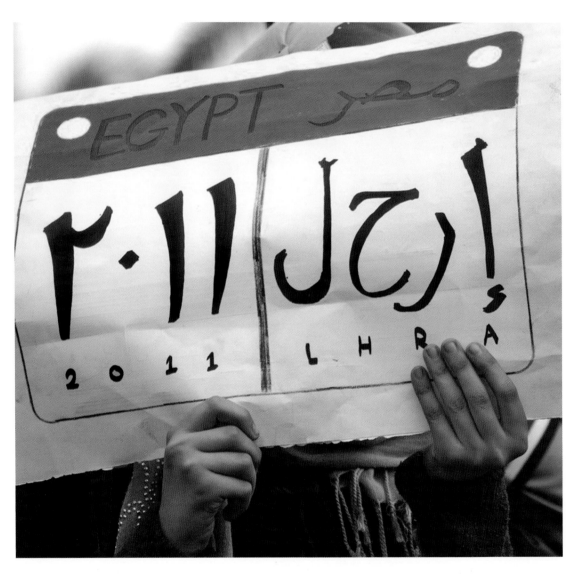

This woman has adapted an Egyptian car license plate,
with 'A R H L' (LEAVE) on the right

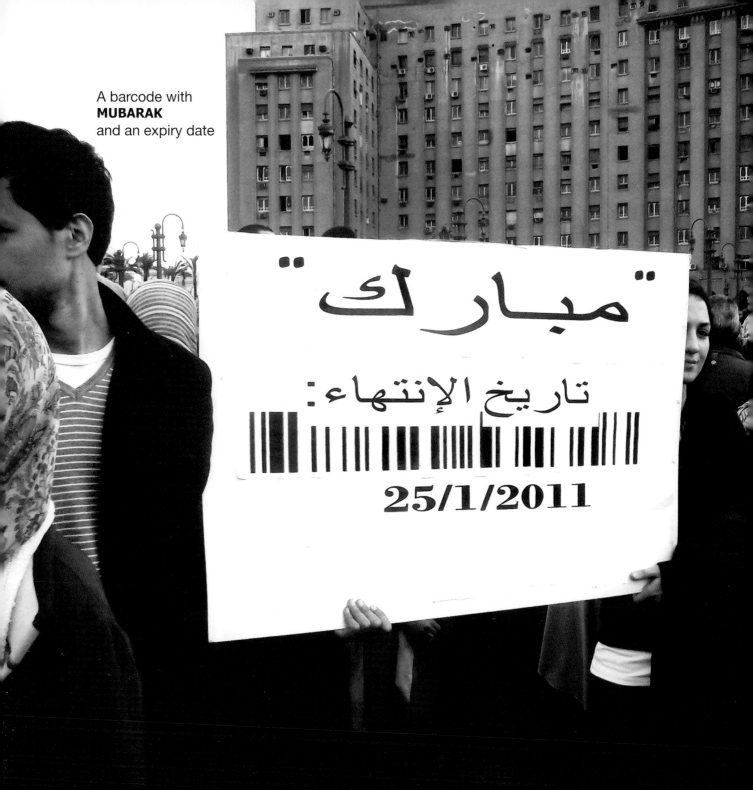

A barcode with **MUBARAK** and an expiry date

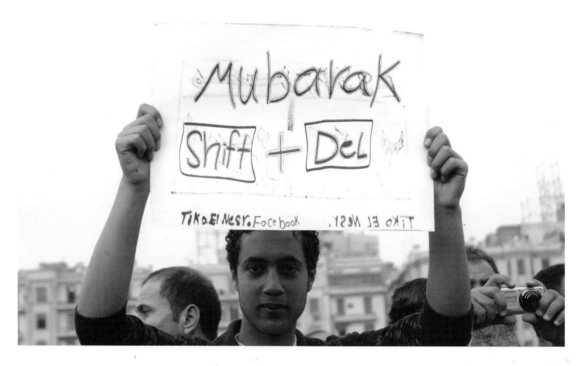

This protester is clear about how completely
he wants to delete the president

The Facebook kids
have **BLOCKED**
Mubarak

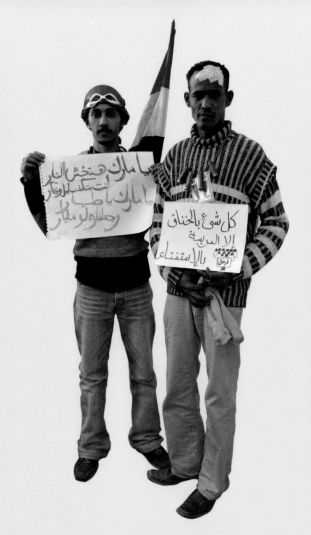

Mubarak you're going to hell
You lie day and night,
Pilot Mubarak,
Give us back at least a billion

Everything can be by force
except being a ruler,
that's by consensus

(these rhyme in Arabic)

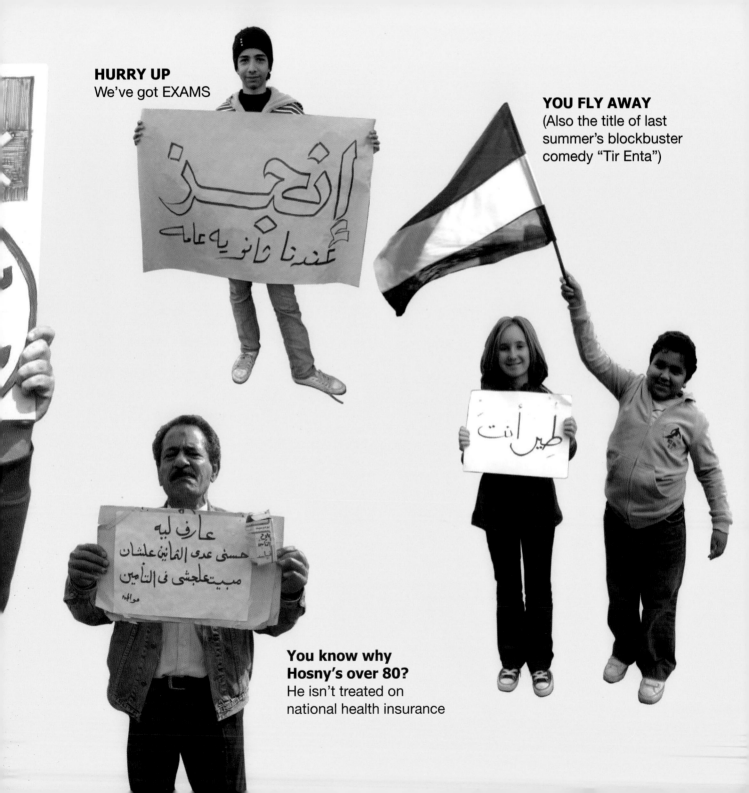

HURRY UP
We've got EXAMS

YOU FLY AWAY
(Also the title of last
summer's blockbuster
comedy "Tir Enta")

**You know why
Hosny's over 80?**
He isn't treated on
national health insurance

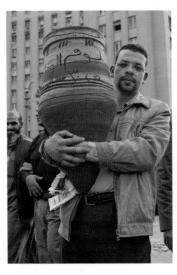 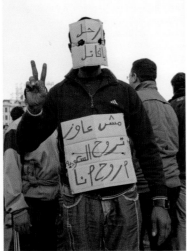 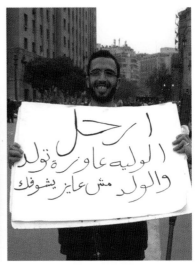

Popular tradition has it that breaking a clay pot (an 'ulla) after an unwelcome guest means they won't come back; this man is holding a large zeer (normally used for cooling water); his meaning is crystal clear to any Egyptian; he's written on it "I've been waiting for this day for 30 years"

(on his face)
Leave, killer

(on his chest)
You don't want to go to Saudi Arabia?
I'll go instead
(Deposed Tunisian dictator fled to exile in Saudi Arabia days earlier)

LEAVE
The wife's in labor and the kid doesn't want to see you

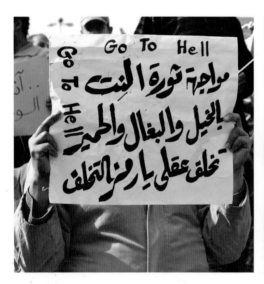

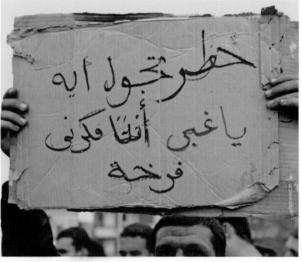

Fighting the Net revolution
with horses and mules and
donkeys is retarded, you retard

What curfew?
YOU IDIOT, DO YOU THINK I'M A CHICKEN

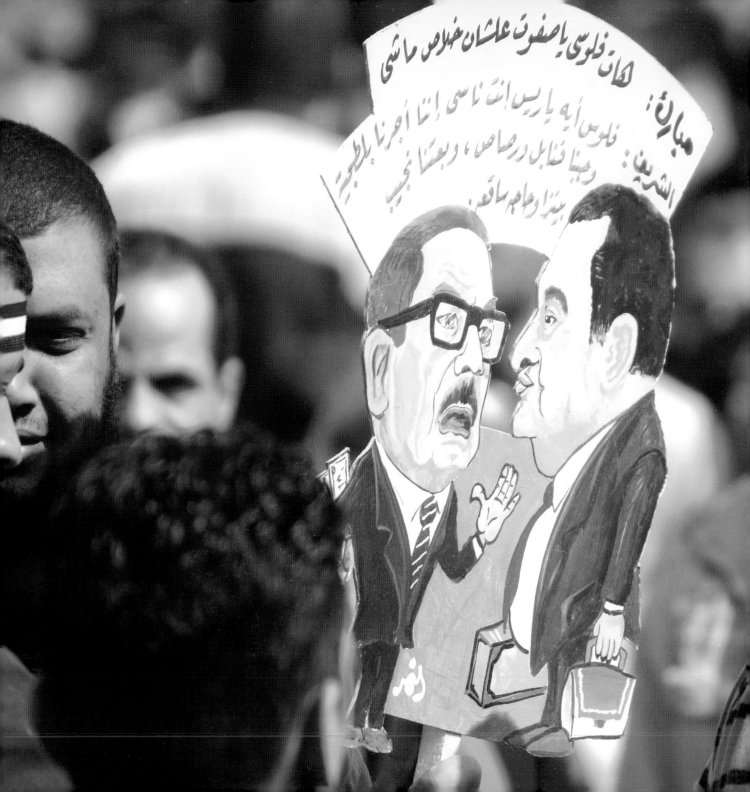

Mubarak *(holding suitcases):*
"Give me my money Safwat, I'm leaving."

Safwat el Sherif *(head of the government's party, the NDP):*
"What money Mr President? Are you forgetting we hired thugs, bought tear gas and bullets and ordered pizza and soda?"

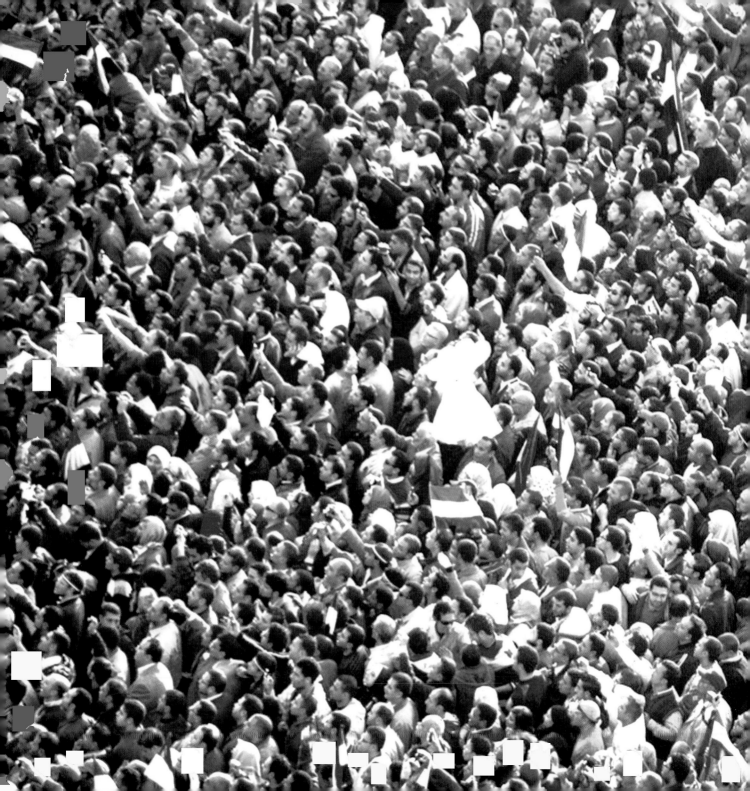

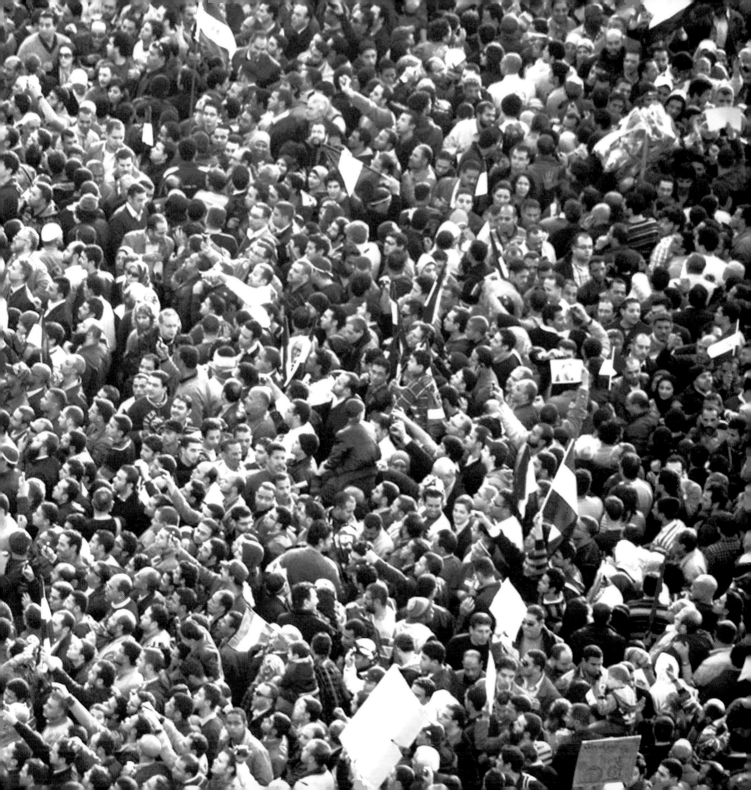

I'm **DESPERATE...**
It's been a week since I've
had any teargas

LEAVE
SHAME ON YOU
MY ARMS ACHE
*(signed Just an
Egyptian)*

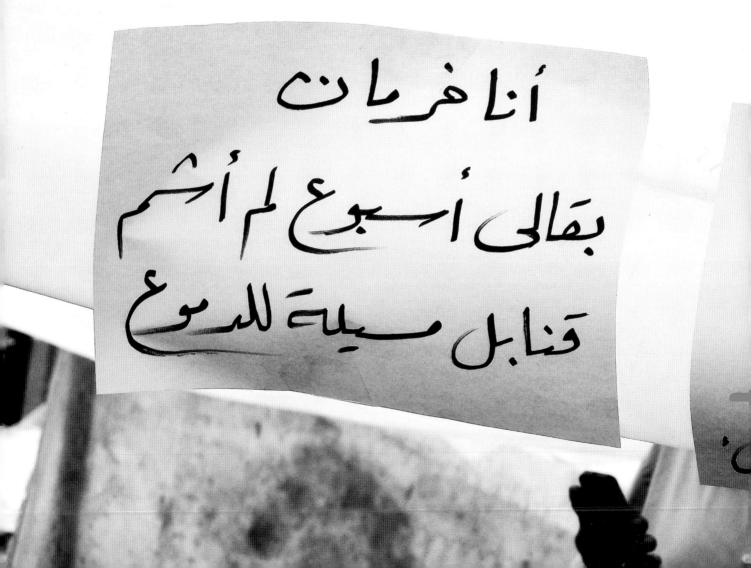

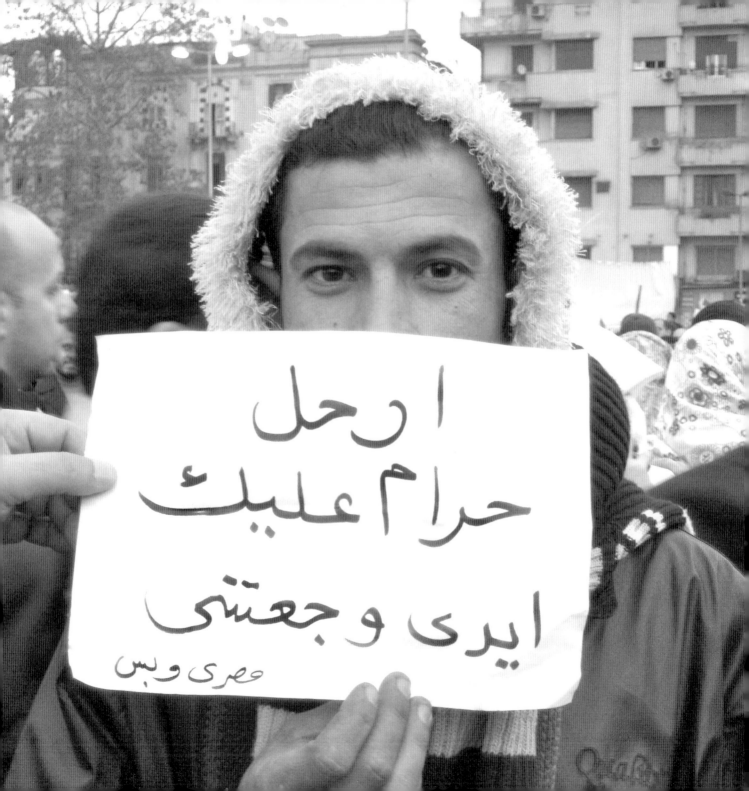

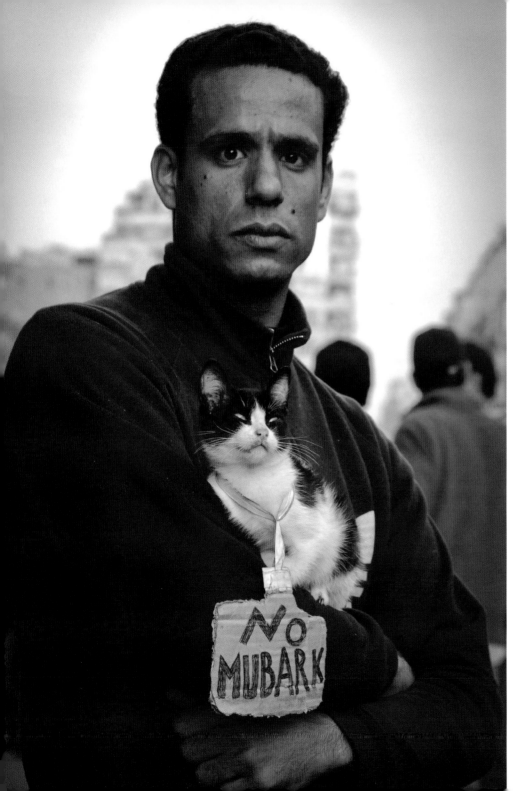

This man deliberately misspelled the president's name

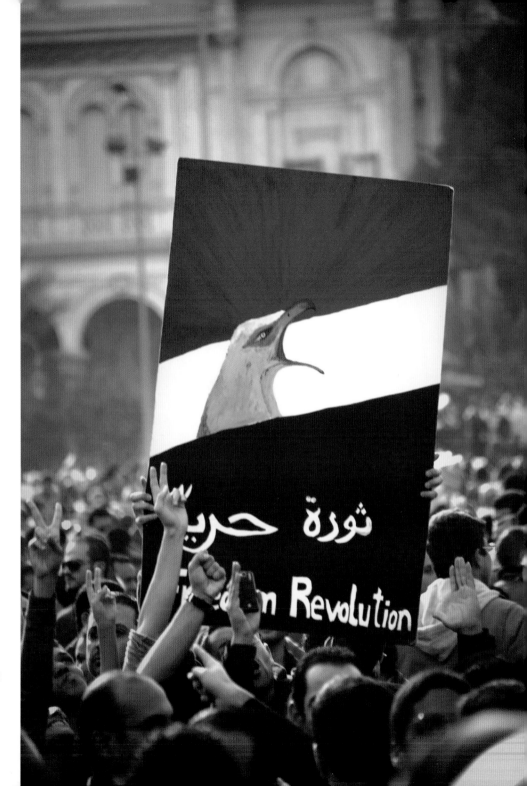

The eagle on the
Egyptian flag strikes a
defiant pose on this sign

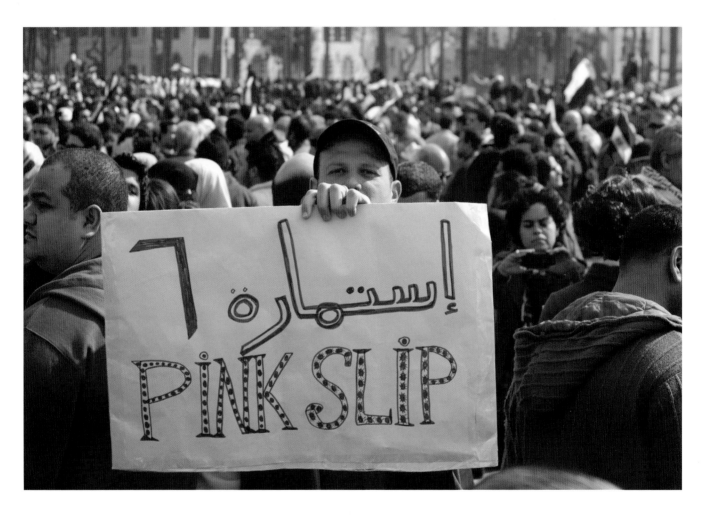

In the U.S. a pink slip means you're fired

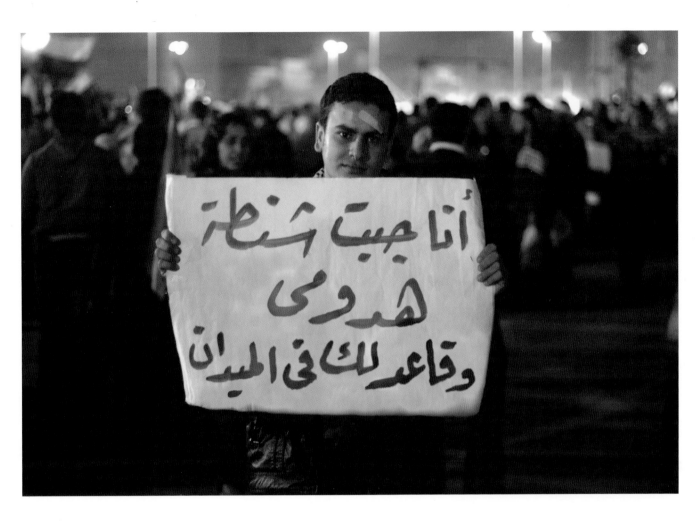

I've brought my bags and I'm waiting in the square

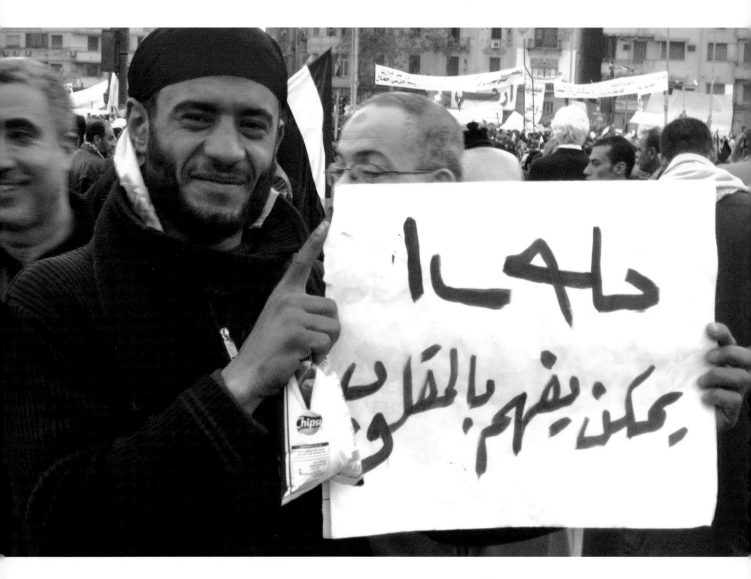

E V A E L
Maybe he'll understand if it's backwards

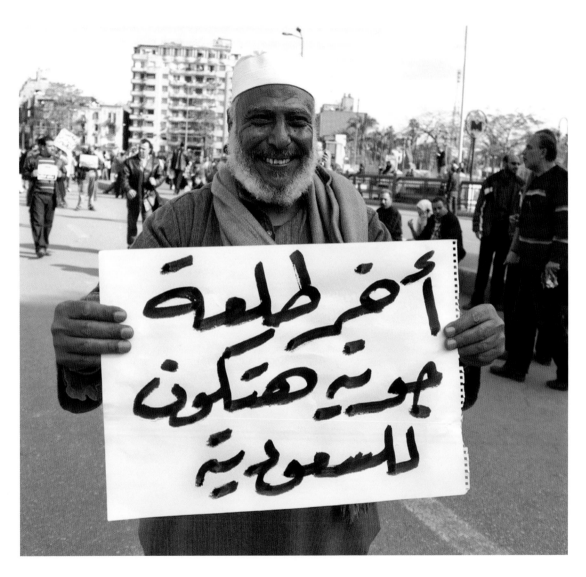

THE LAST AIR SORTIE WILL BE TO SAUDI ARABIA
(The deposed Tunisian dictator fled to exile in Saudi Arabia the week before)

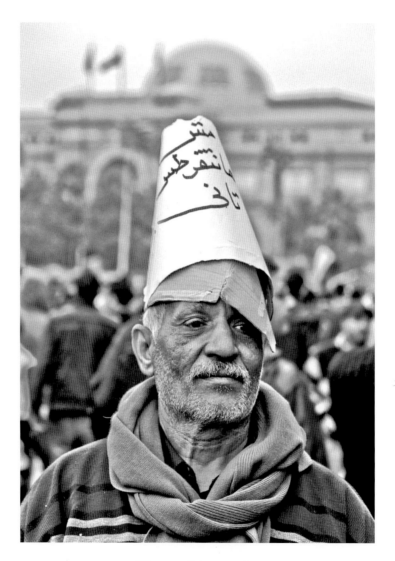

We won't be made
dunces of again

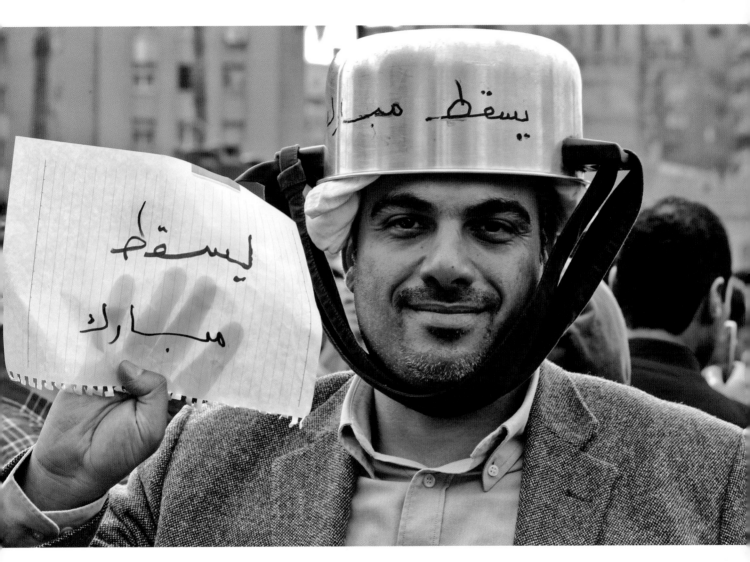

DOWN WITH MUBARAK

Protesters made helmets from whatever they could find

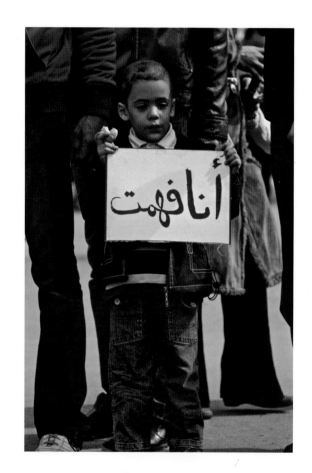

Even I have
understood

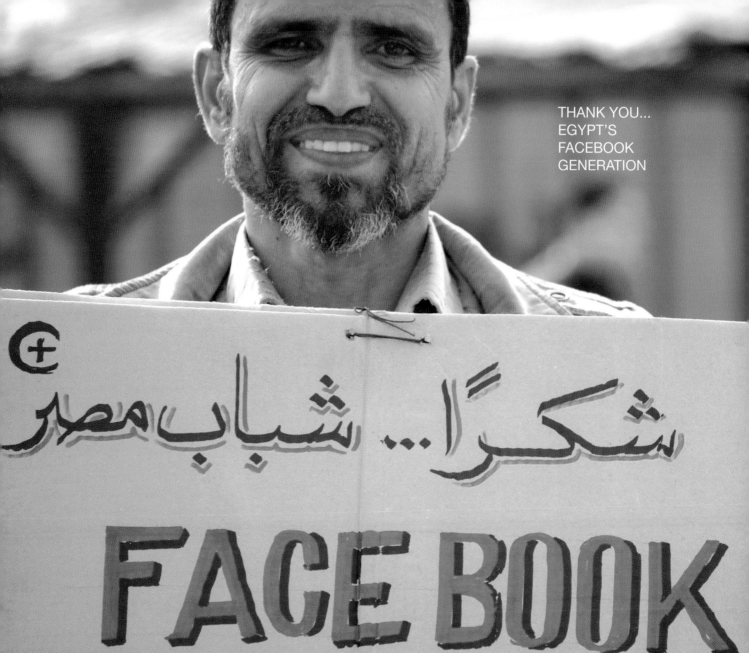

THANK YOU...
EGYPT'S
FACEBOOK
GENERATION

شكرا ... شباب مصر

FACE BOOK

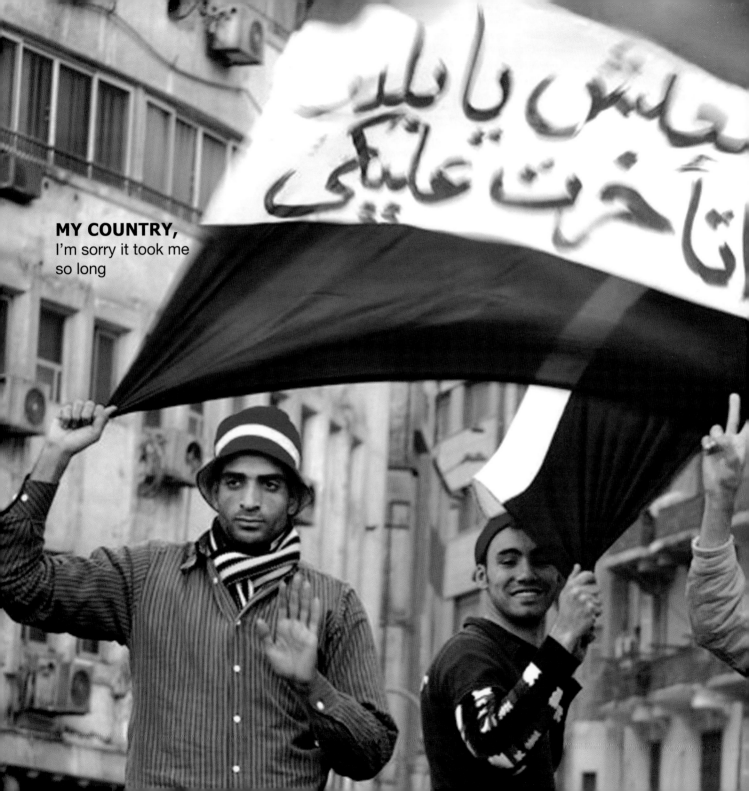

MY COUNTRY,
I'm sorry it took me
so long

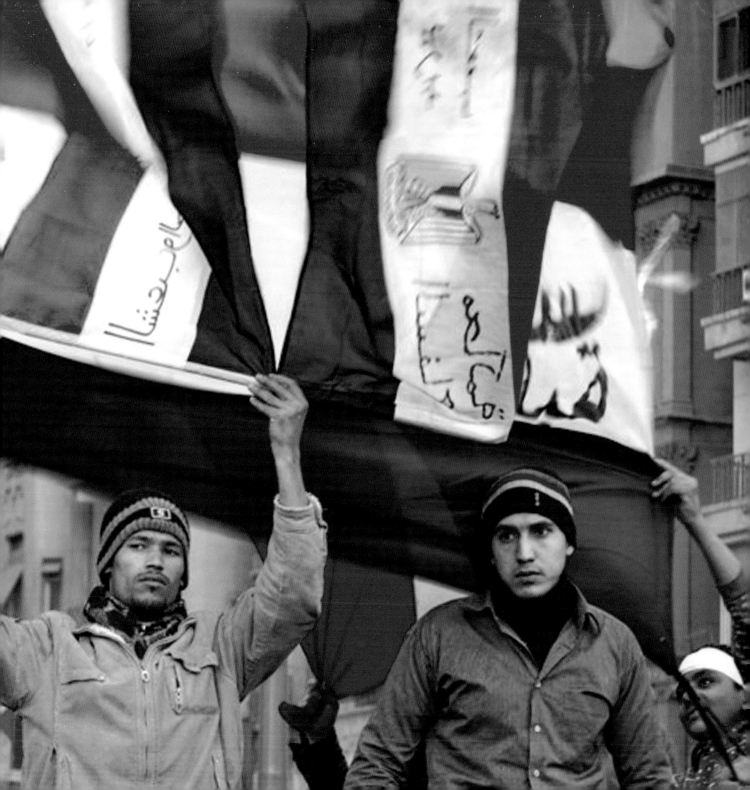

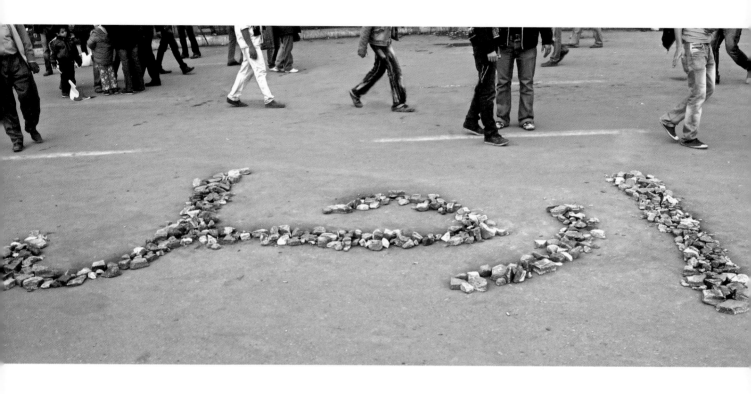

These rocks spell
L E A V E

A kite in the colors of the
Egyptian flag flies above Tahrir,
with the message
"You Fly Away Mubarak"

This protester's resolve is clear,
even if his sign is not

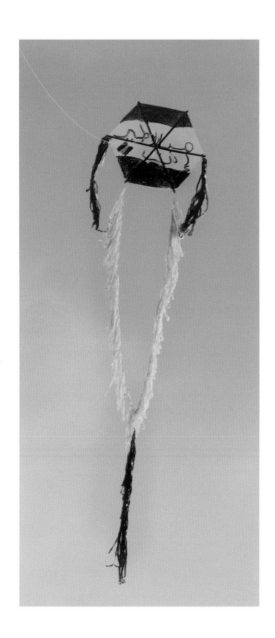

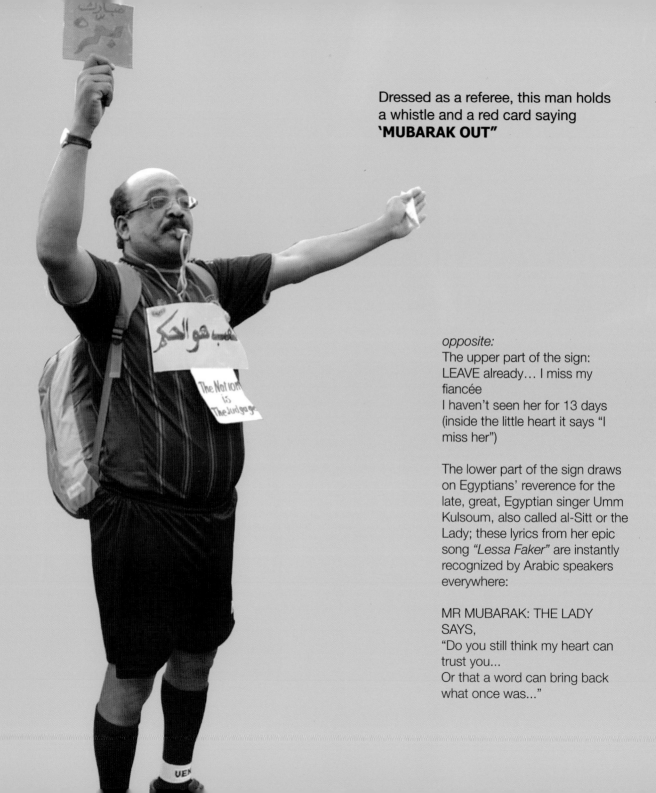

Dressed as a referee, this man holds a whistle and a red card saying **'MUBARAK OUT"**

opposite:
The upper part of the sign:
LEAVE already… I miss my fiancée
I haven't seen her for 13 days (inside the little heart it says "I miss her")

The lower part of the sign draws on Egyptians' reverence for the late, great, Egyptian singer Umm Kulsoum, also called al-Sitt or the Lady; these lyrics from her epic song *"Lessa Faker"* are instantly recognized by Arabic speakers everywhere:

MR MUBARAK: THE LADY SAYS,
"Do you still think my heart can trust you…
Or that a word can bring back what once was..."

وحشتيني ♡

أحبــــــــــي ♡

عاوزة أشوف خطيبي
بقالى ١٢ يوم ماشوفتهاش !...

أستاذ مبارك
السـت بتقـول :

لسة فاكر قلبى يديك أمان ...
والا فاكر كلمة هتعيد اللى كان ...

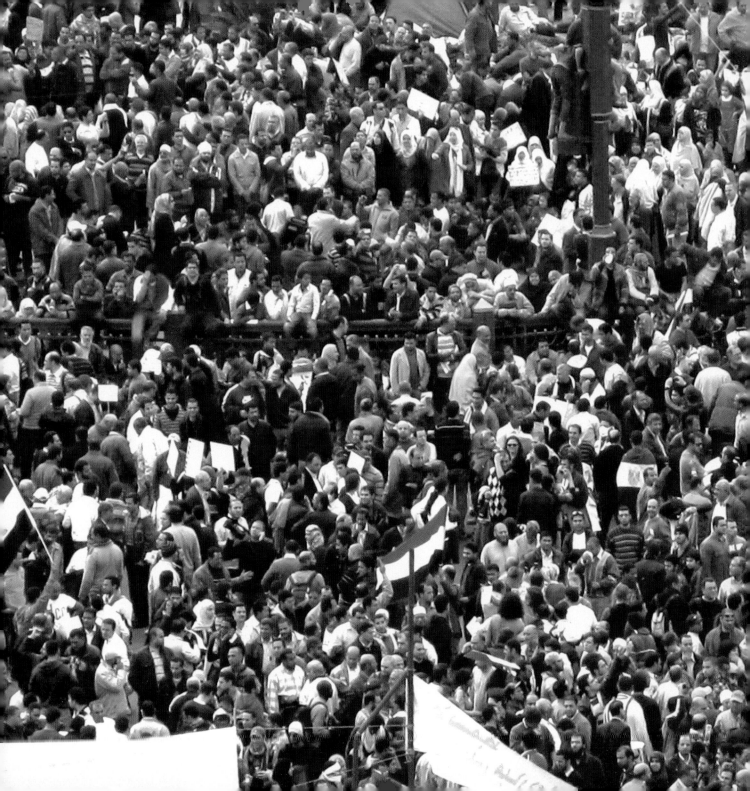

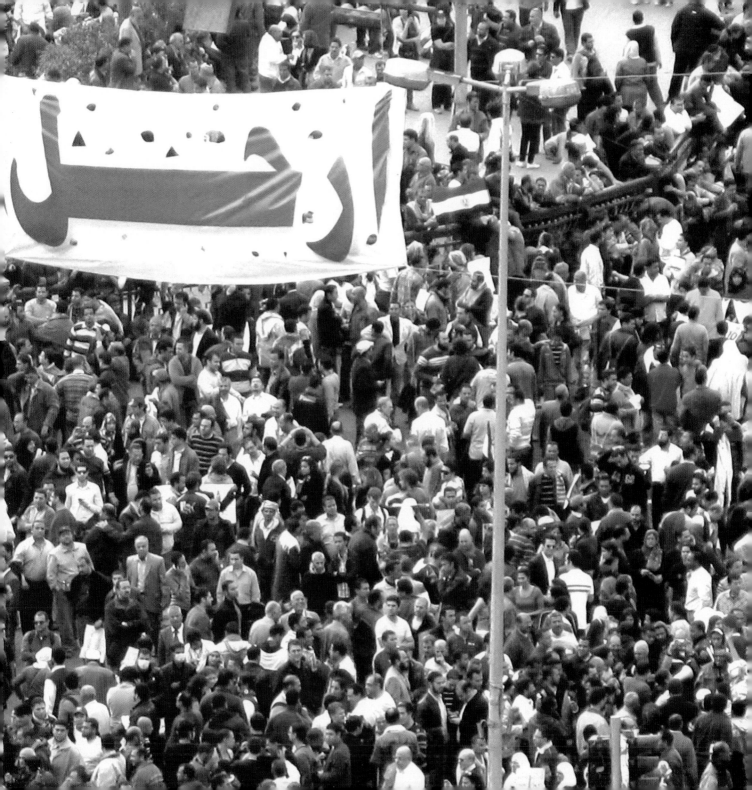

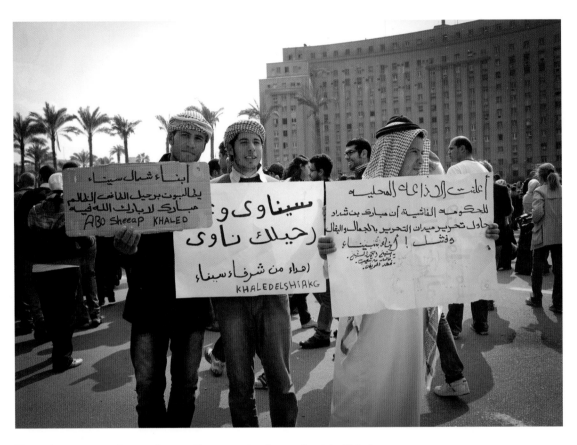

Egyptians came from all over the country to protest in Tahrir
(left) The sons of North Sinai call for the fall of Mubarak the oppressor
(middle) I'm from Sinai And I'm determined you will go
(right) The local broadcast announces that the fascist government of Mubarak ibn Shaddad tried to liberate the square with camels and mules, and he failed! Signed, Sons of Sinai
On 2 February, Mubarak supporters attacked the Tahrir protesters on camels and horseback in what came to be called the Battle of the Camel; 'Antar ibn Shaddad was a pre-Islamic poet and hero

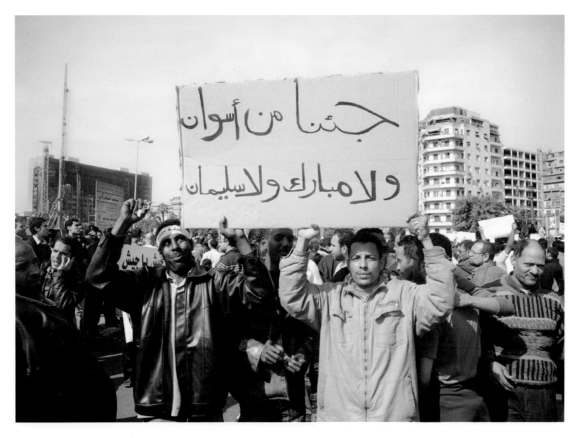

We've come from Aswan
NO to Mubarak and NO to Soliman
Mubarak appointed Omar Soliman vice-president on 29 January,
in an attempt to appease the protesters; anti-Soliman signs
promptly appeared in the square

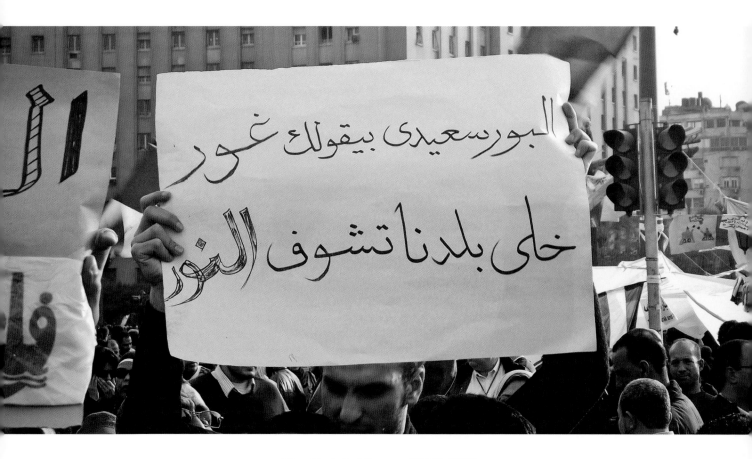

The Port Saidi says GET LOST
Let our country see the LIGHT

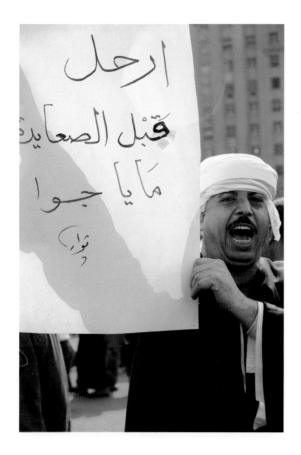

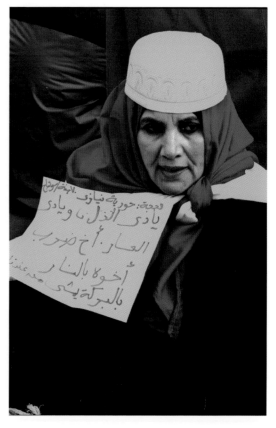

LEAVE
Before the Upper Egyptians
COME
Signed: Revolutionaries

Upper Egyptians are known for being stubborn; the word "come" is written the way it is pronounced in colloquial Upper Egyptian Arabic

Hureya Niyazi, 70, from Sohag
What humiliation, what shame,
brother shooting brother
He leaves with our blessing

Sohag is 400 kms south of Cairo; her headcover is an Egyptian flag

I'm from Sinai
And I'm determined that
you go
You'll leave, you'll leave

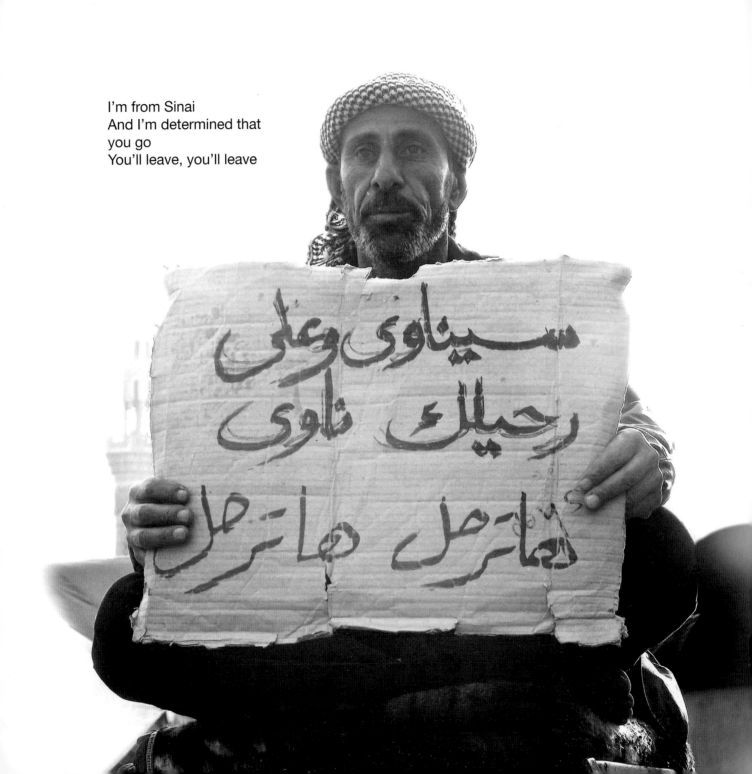

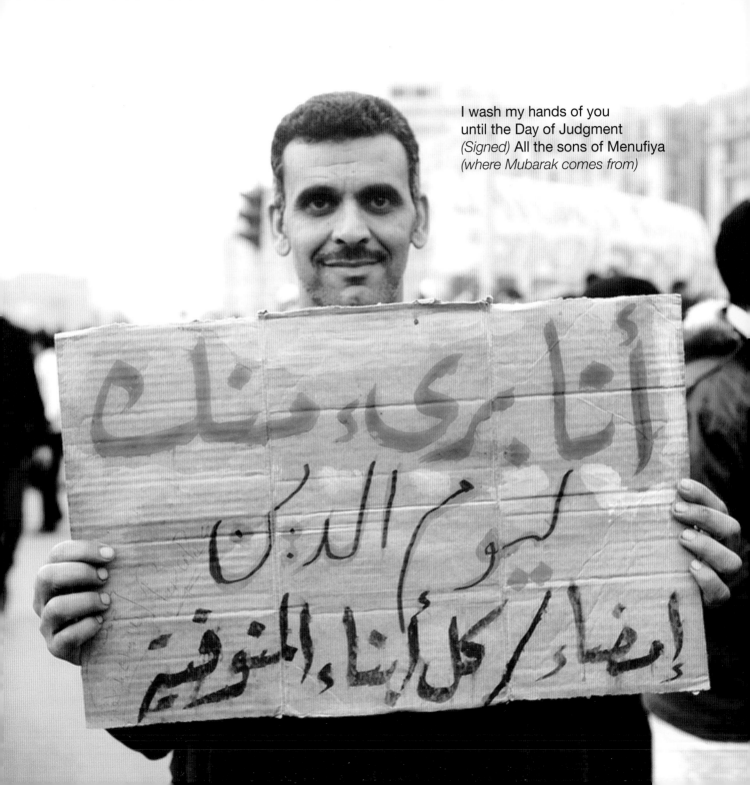

I wash my hands of you
until the Day of Judgment
(Signed) All the sons of Menufiya
(where Mubarak comes from)

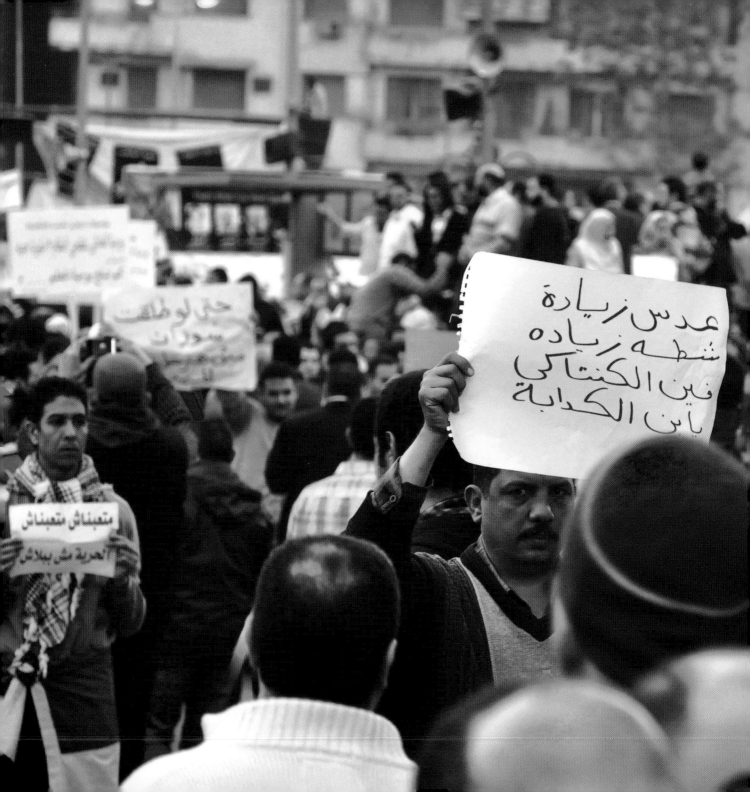

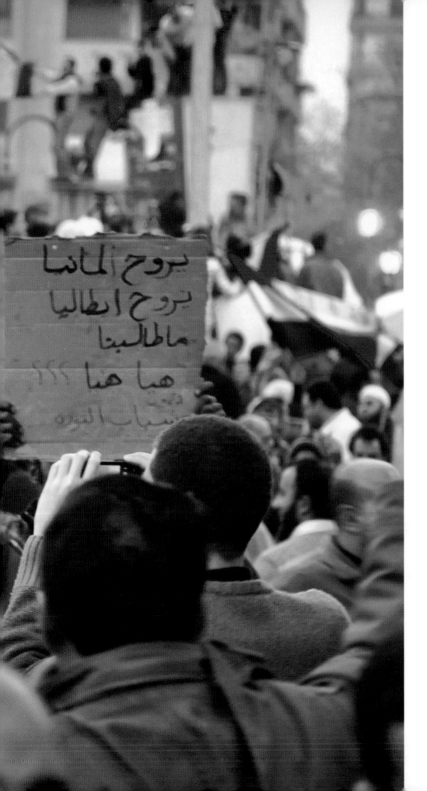

(middle)
More lentils,
More chili,
Where's the Kentucky,
You son of a liar?
*In a transparent attempt to discredit
the protests, the regime spread
rumors that demonstrators were given
Kentucky Fried Chicken meals and
paid 50 euros a day.*

(right)
He can go to Germany
He can go to Italy
Our demands are the same

143

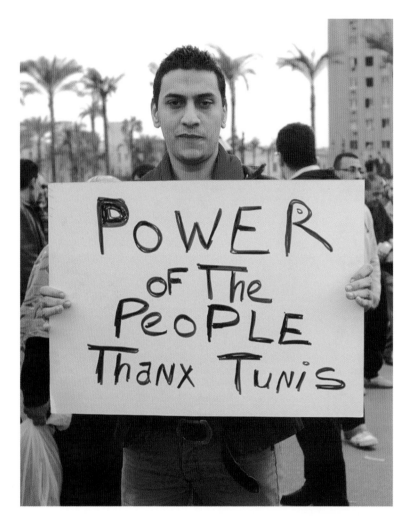

The overthrow of Tunisian president Zine El Abidine Ben Ali, ten days before the January 25 protests in Egypt, showed the Arab world that deposing long-term autocrats was possible; this protester acknowledges that debt

سؤال عايز له جواب
حتقول إيه يوم الحساب

There's a question I need
an answer to,
What will you say on the
Day of Judgment?

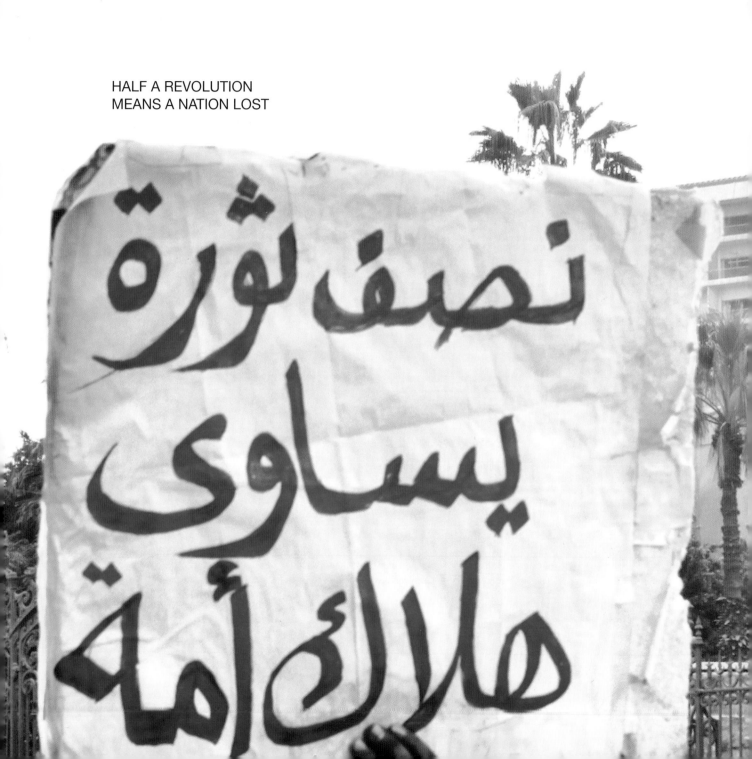

HALF A REVOLUTION
MEANS A NATION LOST

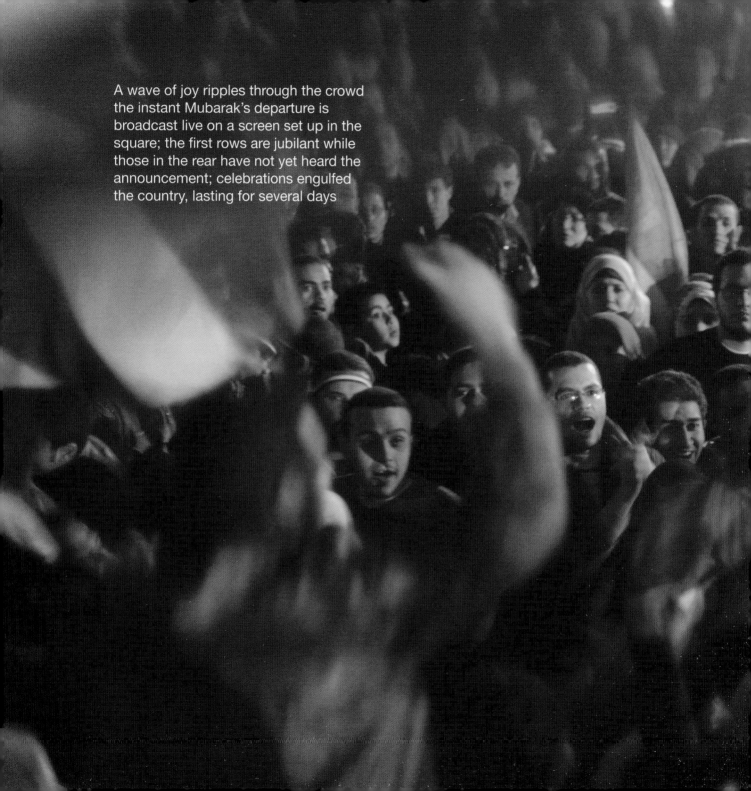

A wave of joy ripples through the crowd the instant Mubarak's departure is broadcast live on a screen set up in the square; the first rows are jubilant while those in the rear have not yet heard the announcement; celebrations engulfed the country, lasting for several days

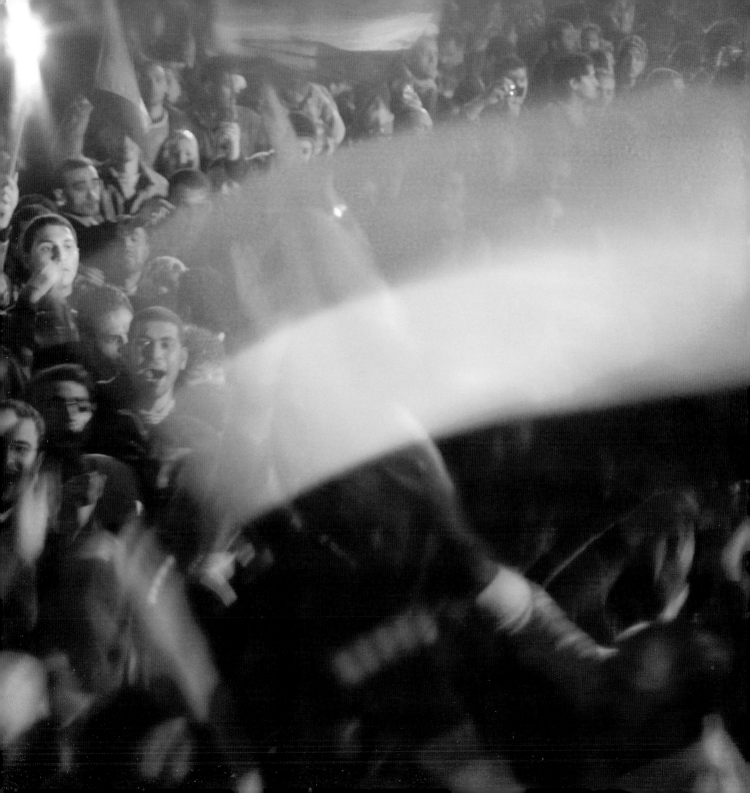

Do not
let your
revolution
be **stolen**
from you

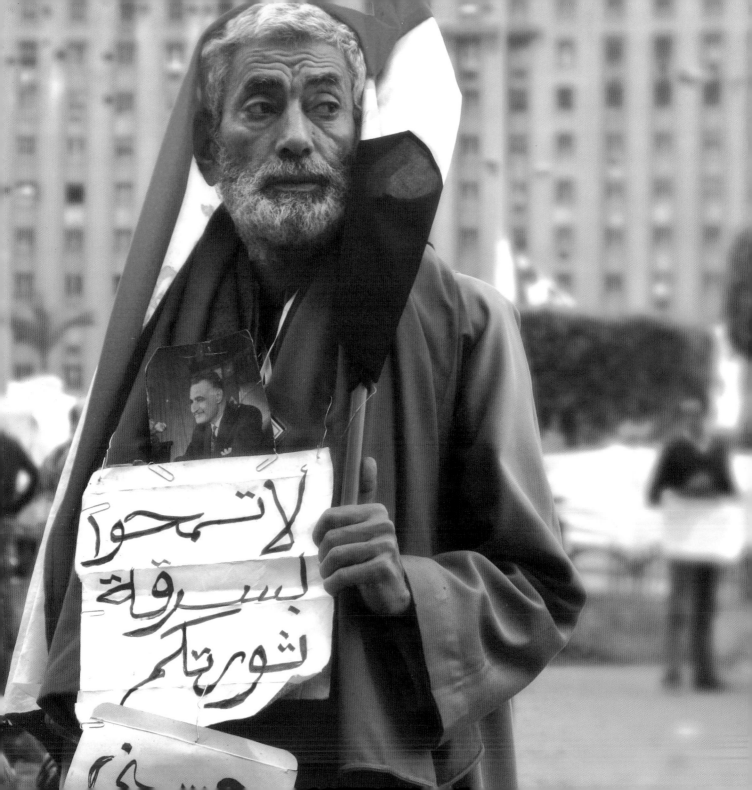

CONTRIBUTORS

Hesham Ali, a 35-year old Hewlett Packard distribution sales manager, didn't realize how much he loved Egypt until he went to Tahrir Square. **Basma Ashour** teaches photography in Alexandria and found being in Tahrir very inspirational. **Ahmed Awney** is an architect who went to protest in Tahrir, taking his tent with him, and was moved to record what he felt and saw with his camera. **Islam el Azzazi**, a filmmaker, photographer, and graphic designer, was responsible—with others—for establishing the independent film scene in Alexandria. **Ahmed Saad Bahig**, 26, is a photographer working in advertising. **Mohamed Boraie** (www.boraiephotography.com) studied economics at the American University in Cairo and is a professional photographer. **Joel Carillet** (www.joelcarillet.com) is a US-based freelance photographer. He is the author of *30 Reasons to Travel: Photographs and Reflections from Southeast Asia*. **Sarah Carr** (www.inanities.org) is a British–Egyptian journalist and blogger based in Cairo. **Rehab K el Dalil**, 21, is studying photography at Helwan University Faculty of Applied Arts. **Mariam Darwish**, 23, a freelance photographer, is a teaching assistant at Cairo University. **Mohamed Ezz Aldin** (www.facebook.com/EzzPhotography) is a 30-year-old self-trained photographer who enjoys seeing the world through his viewfinder. **Beshoy Fayze** graduated from the Faculty of Arts at Cairo University, having studied Japanese. He wants to use his camera to make people smile. **Mohamed Gabr** (www.mgabr.com) is a Cairo-based fine art and advertising photographer who executes work for multinational companies in the Middle East, Africa, and Asia. **Zeinab Mustafa el Genndy** (www.egyptianchronicles.blogspot.com) is a 27-year-old blogger who writes about Egypt and who covered the protests from Day 1. **Hossam el Hamalawy** (www.Arabawy.org) is a journalist, blogger and activist with Egypt's socialist movement. **Maged Helal** is a 25-year-old administrative assistant at the American University in Cairo. His photos of Tahrir Square are his pride and joy. **Rania Helmy** (https://www.facebook.com/?ref=home#!/pages/Rania-Helmy-Photography/212368708788031?sk=photos) is a freelance public relations consultant, travel photographer, and photojournalist. **Ghazala Irshad** is an American multimedia journalist pursuing a Masters at the American University in Cairo's Kamal Adham Center for Journalism

Training and Research. **Nour Kamel**, a 22-year-old American University in Cairo graduate and amateur photographer, works in advertising. **Karima Khalil** graduated from Smith College, Ain Shams Medical School, the London School of Hygiene and Tropical Medicine, and is an avid photographer. **Omnia Ibrahim Magdy**, a Sadat Academy graduate, provides technical support for an IT firm. Omnia saved up for a professional camera and taught herself photography on the internet. **Mohamed Mekhamer** is a photographer who felt the best way he could take part in the Egyptian revolution was by documenting it with his camera. **Sherif el Moghazy**, 39, is a documentary filmmaker. He returned to Egypt on 23 January to take part in the protests and help create a better Egypt for his daughter. **Noha Ali Mohamed** is a Faculty of Commerce graduate whose passion is photography. **Ahmed Mostafa**, an accountant in an oil company, never dreamed he would witness a real revolution. He abandoned his usual nature photography to document the protests. **Amr Nabil** is a professional photographer with the Associated Press and a founder of the Egyptian Photojournalist Society. **Tarek Omar**, 34, is an electrical engineer and IT program director at Misr International University who believes in making a difference. **Mariam Saeed Omar**, 21, studies applied arts at Helwan University. **Mohmed Osman** is a 32-year-old amateur photographer and credit control specialist with Vodafone. **Hamdy Reda** is a professional photographer and the founder of Artwella. **Mohamed el Sehrawy** (www.sehrawy.net) a 24-year-old German University in Cairo engineering graduate, does photoshoots for local and international clients. **Rehab Sobhi** has a bachelor's degree in architecture and took up photography a year ago. **Amr Soliman** (http://www.flickr.com/photos/solilos/) is a freelance photographer based in Cairo. **Mariam Ehab Soliman**, 18, is a student at the Deutsche Schule der Borromaerinnen in Cairo. During the revolution she posted her photos on the net so the world could watch Egypt gain freedom. **Shahira Tarek Zaki** is a freelance photographer who wants Egypt to be proud of her. **Stefania Zamparelli** (http://www.zamaprelli.us) is a widely-published independent photographer. Based in New York, she travels extensively and is a founding director of Community Awareness Through Arts Inc. a Brooklyn-based non-profit organization.

PHOTO CREDITS

(a) = above, (b) = below
(l) = left, (r) = right, (m) = middle

1	Zeinab Mustafa el Genndy	52	Sarah Carr
2	Ghazala Irshad	53	Sherif el Moghazy
5	Ahmed Mostafa	54-55	Hossam el Hamalawy
6-7	Islam el Azzazi	56-57	Hossam el Hamalawy
8-9	Sarah Carr	58	Hossam el Hamalawy
10-11	Hossam el Hamalawy	59	Beshoy Fayze
12-13	Nour Kamel	60	Hossam el Hamalawy
14-15	Shahira Tarek Zaki	61	Ahmed Saad Bahig
16-17	Beshoy Fayze	62	Karima Khalil
18-19	Islam Azzazi	63	Ghazala Irshad
20	Omnia Ibrahim Magdy	64-65	Amr Soliman
21	Amr Soliman	66	Islam el Azzazi
22-23	Karima Khalil	67	Mohamed Boraie
24-25	Karima Khalil	68 (l)	Karima Khalil
26-27	Joel Carillet	68 (r)	Nour Kamel
28 (l,r)	Ghazala Irshad	69	Omneya Ibrahim Magdy
29	Mariam Soliman	70 (l)	Sherif el Moghazy
30 (l,r)	Mohamed Gabr	70 (r)	Nour Kamel
31	Sherif el Moghazy	71	Sarah Carr
32-33	Hossam el Hamalawy	72 (l)	Sherif el Moghazy
34-35	Mohamed Mekhamer	72 (r)	Mariam Saeed Omar
36	Rehab Sobhi	73 (l)	Ghazala Irshad
37	Omneya Ibrahim Magdy	73 (r)	Mariam Darwish
38-39	Amr Soliman	74 (a)	Noha Ali Mohamed
40	Amr Soliman	74 (b)	Nour Kamel
41	Hossam el Hamalawy	75	Hossam el Hamalawy
42-43	Amr Soliman	76	Amr Soliman
44-45	Hossam el Hamalawy	77	Hossam el Hamalawy
46-47	Hossam el Hamalawy	78-79	Karima Khalil
48-49	Karima Khalil	80-81	Rania Helmy
51	Hossam el Hamalawy	82	Mariam Darwish

ACKNOWLEDGMENTS

I would like to thank Pierre Sioufi for his friendship and for his hospitality in Tahrir. Many were very generous with their time in the making of this book. Ahmed Ali Fawzy helped me track down many of the talented photographers whose work is shown here. I am grateful to Menna Hamed, Wael Point, Essam Sharaf, Maryam Helmy, Khaled al Desouky, Daniel Demoustier, Bernard O'Kane, and Dana Smillie for their professional generosity. Marwa el Shazli, Dina Sidahmed, Mohamed Abulghar, Minou Hammam, Marcia Lynx-Qualey, Duro Olowu, Sylvie Franquet, Salma Khalil, Jaylan Zayan, Balsam Saad, Jonathan Wright and Khaled Dessouki all helped in various ways. I am grateful to Seif Salmawy for his enthusiasm and for his understanding. Rebecca Porteous's editorial insights and constant support were invaluable as always and I am indebted to Issandr El Amrani for rescuing the book from last-minute disaster. I was very lucky to work with Amr el Kafrawy, whose very considerable talent as a designer is matched only by his patience. Finally, my debt to the brave men, women, and children who stood their ground to change our country is beyond words.